POP ART

CREATE YOUR OWN STRIKING WALL ART

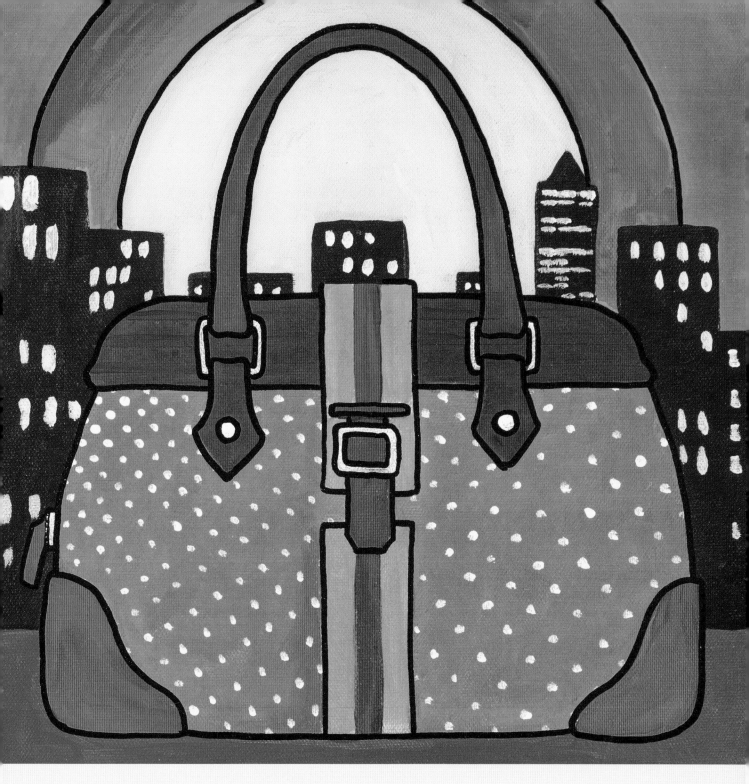

Thomas Böhler

Pop Art

CREATE YOUR OWN STRIKING WALL ART

Thomas Böhler lives and works in Freiburg im Breisgau in Germany. Having studied education, with an emphasis on adult education, he has been a freelance illustrator and graphic artist since 2006. He has written numerous articles on drawing and painting, and his artistic works include drawing and experimental mixing techniques as well as acrylic painting.

www.t-boehler.de

First published in Great Britain in 2016 by
Search Press Limited,
Wellwood, North Farm Road,
Tunbridge Wells, Kent TN2 3DR

First published as *Acrylmalerei Pop-Art ganz einfach*
Original edition © 2014 World Rights reserved by
Christophorus Verlag GmbH & Co. KG, Freiburg, Germany
Copyright © 2014 Thomas Böhler

English translation by Burravoe Translation Services

Picture credits: Page 4: Nicole Kemper; pages 8, 9 top, 11, 17 bottom, 18, 21, 22/23 bottom, 24/25 bottom, 28/29 bottom, 34/35, 36 bottom, 39, 41, 43, 45, 49, 51, 53, 55, 57, 58 bottom, 59, 61 and 63: Frank Schuppelius; all others and step photos: Thomas Böhler

ISBN: 978-1-78221-233-1

Printed in China

CONTENTS

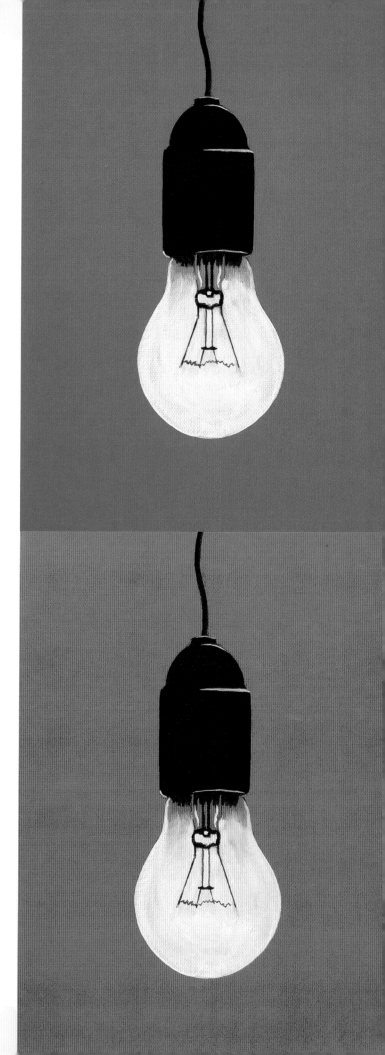

INTRODUCTION

If you like painting figuratively, painting in the Pop Art style could be just the thing for you! Pop Art runs counter to abstract art: the subjects are greatly simplified and usually shown two-dimensionally, and impressive images are created entirely without difficult colouring or complicated structures. This book contains a wide range of examples with varying levels of difficulty so there is plenty of choice for everyone. Some of the motifs were inspired by well-known Pop Art artists such as Andy Warhol and Roy Lichtenstein, while others take their inspiration from the modern world.

One of the most important things with Pop Art is to 'reduce the representation' – in other words, to simplify a complex image and transform it into the clear, simple language of Pop Art. You will find your daily surroundings full of objects that are perfect to use as motifs and can be easily adapted in the typical Pop Art style.

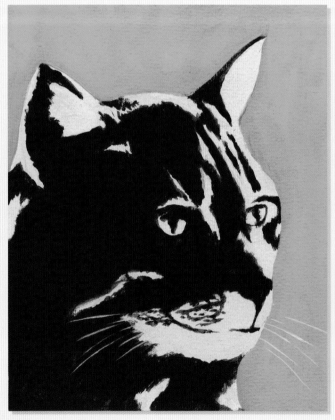 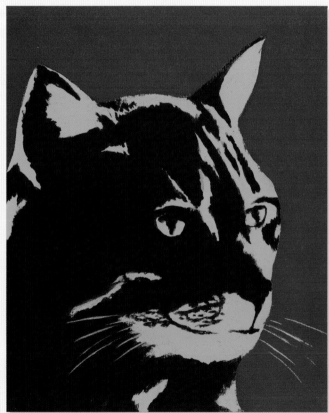

When starting out, it is probably easiest to simply copy the motifs to use them as patterns or templates. Of course, you can change the colours of your chosen motif if you wish, or use different materials and tools from those I suggest. You will be surprised at how quickly you are able to move on to the next step, and will soon start having your own ideas.

The start of the book contains information on materials and tools along with a few basic techniques that will show you how to turn a photograph or a real object into a picture. Whether you consider this kind of drawing as a decorative hobby or are more ambitious about it and want to create your own works of Pop Art, I hope – and this is my main goal in writing this book – that you develop a passion for it and derive great pleasure from it!

Thomas Böhler

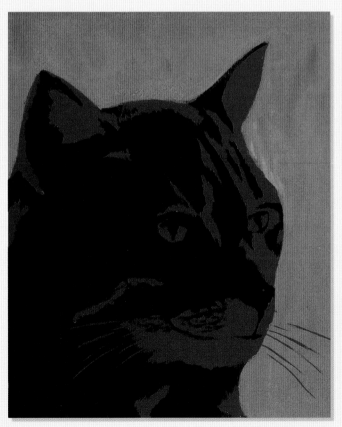
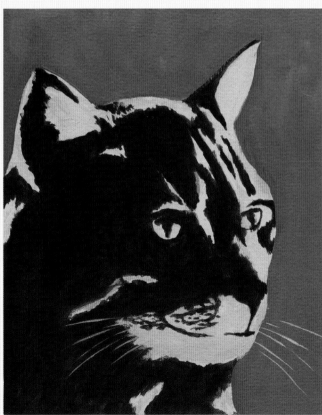

WHAT IS POP ART?

The name 'Pop Art' is short for popular art, which may make you think of sentimental movies and brass bands. But rather than being old-fashioned, Pop Art was intended to focus on the spirit of the moment, and to turn daily life into an artistic theme. It was a reaction to abstraction, which was considered elitist.

Even back when Pop Art was first created, in mid-1950s Great Britain and the USA, daily life was already dominated by mass consumption. People were surrounded by goods produced in large quantities. These products became the subjects of Pop Art. The focus was no longer on the classic still life with a vase and bowl of fruit. Instead, the artists took their inspiration from everyday items and advertisements, such as soft drink brands or other familiar groceries – Campbell's soup was made world famous by Andy Warhol (1928–1987), for example.

This transformation included people as well as objects. Before Pop Art, portraits were traditionally of leading personalities who were considered 'elite' and distant, such as important thinkers, politicians, the nobility and members of the church. Pop Art instead focused on the average citizen's idols: people from pop culture – famous singers, actors and even comic book characters.

Clearly defined objects, pure colours and poster-like representations were typical of this style of drawing and painting, and also of the images used in Pop Art. There is

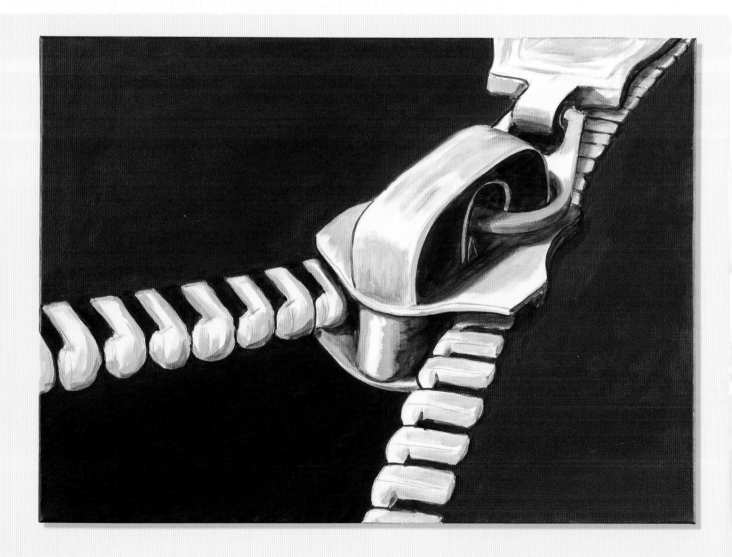

not the slightest hint of spatial effect or three-dimensionality. Another typical feature is the contouring of areas and shapes in thick black lines, which has the effect of putting the element in isolation, an effect often used in advertising or collages. Serial reproductions – multiple copies of the same image, with minor variation – are another typical feature of Pop Art.

The most famous Pop Artists include Andy Warhol, Roy Lichtenstein (1923-1997), Claes Oldenburg (1929-present), Robert Indiana (1928-present) and Tom Wesselmann (1931-2004). They were innovative in their use of techniques. Screen printing, for example, had previously been used only for practical and advertising purposes, rather than in art. Pop Artists began to use it to produce several repeated pictures of a particular motif in various colours; Andy Warhol's famous series of Marilyn Monroe portraits being perhaps the most iconic example. Claes Oldenburg even created Pop Art sculptures from papier-mâché and waste materials.

Everyday items, such as a pickaxe or garden hose, were often oversized in Pop Art. This book uses a zip (see page 28) to illustrate this particular principle, which could easily be transferred to other objects. Just think: drawing pins, sewing needles or matches, to name but a few. Take a look around – lots of little objects are worth considering.

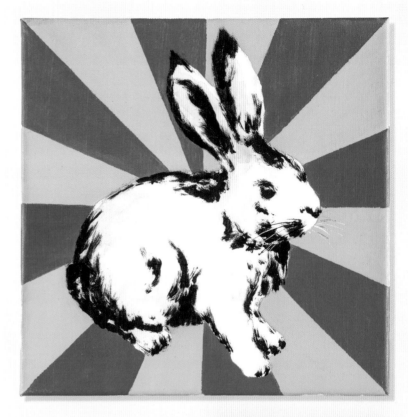

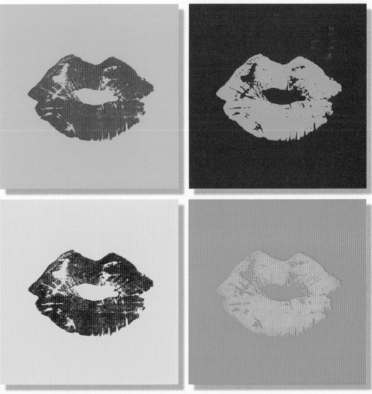

MATERIALS AND TOOLS

Acrylic paints

When it comes to choosing colours for your Pop Art, you are spoilt for choice, since you can use almost any paints available. Acrylic paints are a popular and practical option. They provide good coverage, the colours are bright, and they dry quickly. This is a particular advantage in Pop Art. Unlike gouache and watercolour paints, acrylic paints are waterproof when dry, which means they can easily be drawn or painted over.

Nevertheless, a single application of acrylic paint is usually not sufficient to achieve a cleanly covered surface, as the base will shine through and the painted area can look patchy. By the same token, if the paint is too thick, the area can look uneven and restless. As a result, it is best to start out knowing that you will have to apply the paints in a number of thin layers.

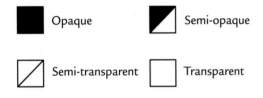

Not all shades provide the same level of coverage. Most paint manufacturers identify the various levels of coverage of their paints (see diagram above). In the example shown below left, the pencil lines show through the transparent pink paint a little. The blue has been tinted with a little white, with mixing white on the right and titanium white on the left. It is quite clear to see that titanium white provides better coverage.

It is sometimes necessary to paint a transparent colour over another colour (see below right), perhaps in order to correct an error. Cover this area in titanium white, allow it to dry, and then paint over the new colour.

Painting surfaces

All standard painting surfaces are suitable for acrylic painting, but stretcher frames, which are available in lots of sizes and formats, are particularly good. Boards where the canvas is simply attached to cardboard are a less expensive alternative.

You can also use watercolour paper or artist's board. The latter is quite thick so it does not cockle when coated with wet paint. Avoid cartridge paper, which will quickly buckle when wetted.

Plywood and hardboard are also suitable grounds. It is a good idea to prime them before painting, as otherwise the paints can look quite dull. Wooden boards should not be too thin – at least 5mm (¼in) – as otherwise they can warp. As a general rule, the bigger the board, the thicker it should be.

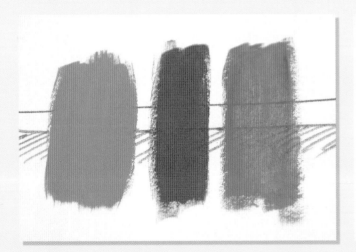

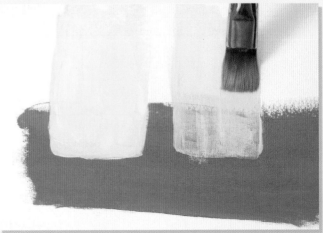

Tools

Brush marks are not a desirable feature in Pop Art, and so I recommend brushes with soft synthetic fibres, as they achieve even, smooth results. I like to use a 30mm (1¼in) flat brush for priming, no. 8 and 14 flat brushes for the motifs, and a no. 4 round brush for the details.

Choose the size of the brush to suit the format and the shape of what you are painting. As a general rule, opt for larger brushes when painting large areas, since smaller ones will make for a restless application of the colour and require tremendous patience. Use fine brushes and dilute the paint slightly to make sure it flows well for the finer details.

Details are even easier with a coloured pen or marker. Experiment first to make sure that your pens are suitable for your particular purpose. The Paint Marker 750 by Edding and PITT Artist Pen by Faber-Castell are excellent, since both provide sufficient coverage.

Depending on your project, you could also apply the paint with a spatula. Take time to choose your favourites from the many different types of painting spatula.

You will also probably need a pencil for sketching, and if you are using acrylic paints you will also need a water container and a palette.

Collage elements

Coloured paper and cardboard are ideal for collages and basic shapes. You can also colour your own papers. However, you will probably have to iron the paper once it is dry to make sure it is smooth and even.

Coloured tape is currently extremely popular in the art world, and can be applied to almost any surface. Surfaces should be dry and not too rough. However, tape is really only suitable for straight lines.

FROM MOTIF TO PICTURE – THE TECHNIQUES

How do I get from an object or photograph to my finished Pop Art-style picture?

As Pop Art motifs are extremely bold, and simplified in large areas, there are a number of things you need to do. Start by removing the details, and reduce the number of tonal areas. Use strong, clear colours if at all possible.

This reduction in shapes and colours is a step in abstraction that is not always entirely easy to carry out. However, there are various technical and artistic tips and tricks you can use to make it easier. The following pages explain the main techniques and information.

Find the shape

Practise finding the shape of a simple object – a banana, for example. Although its long, slightly rounded shape will undoubtedly be very familiar, it is not always easy to get it absolutely right first time. However, all you need is drawing paper and a pencil, and you can get started.

1 Start drawing the shape of the banana with the pencil. You might find it helps to draw a few straight or rounded reference lines that go beyond the outline. Use increasingly long strokes to get closer to the shape. Although you can now see the actual contour, you will probably find that it smudges if you draw over it in pencil.

2 Draw or trace this basic shape again on a new sheet of paper (see right).

3 If you then apply transparent colours – like the yellow used here – you will still be able to see some of the pencil lines. Once the paint is dry, you can then draw around these lines and contours with a pen or detail brush. It is a little more difficult to do with a brush, but this does create livelier lines since you can vary the thickness of the lines.

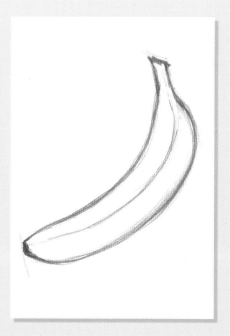

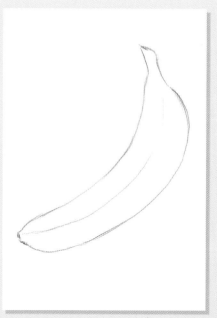

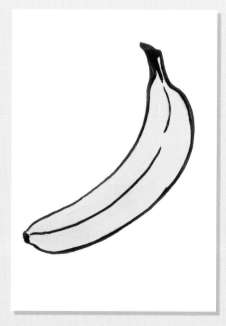

From photograph to motif

It is easier if you base your work of art on a photograph. There are various ways and techniques to copy from a photograph – just try it!

Using tracing paper

 If you have a suitable photograph, you can simply trace over it onto tracing paper for your original. The advantage with tracing paper is that the opacity will prevent you from wanting to trace every single detail. You can only identify large shapes and differences in tone. Draw along these dividing lines in pencil.

Draw pencil hatchings to join the areas, then choose your colours. It is a good idea to dispense with shades when drawing like this, so consequently grey and white areas should be clearly distinguishable from each other. You can now enlarge your template using either a photocopier and transferring the shape, or by copying it onto your chosen surface.

Tip:

If your photograph has large contrasts but too many details, place several sheets of tracing paper on top of each other to obscure some of the lighter tones completely.

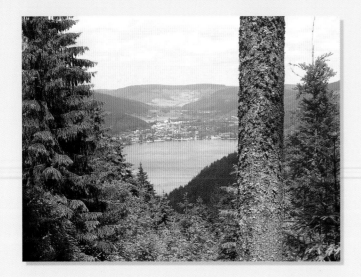

Tip:

*If you are using a computer
for this, all you need is
a photograph taken with
a basic camera.*

Using a computer

If you like using a computer, you can use one here. You will need an editing program such as Photoshop Elements or GIMP (shareware). In this example, Photoshop Elements has been used for the editing. The menu commands of most programs are similar, so even if some of the names are different, you will quickly learn to find your way around a different graphic editing program.

1 We will start with a basic picture of a sea view, so you will not need any special equipment for this kind of template. The only time you could have problems is with very small image files.

2 Some photographs will provide better results if you first increase the contrast. Use the commands Image; Adjustments; Brightness/Contrast.

3 Use the sliders to alter the levels, but be careful not to go too far. Make sure that preview is active, and you will immediately see what is happening.

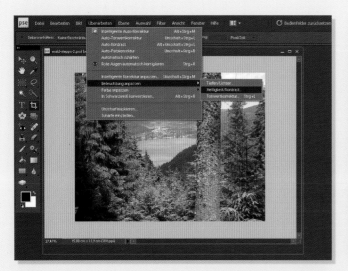

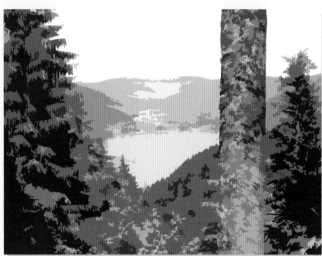

4 You will find lots of suggestions to choose from in the menu bar under Filters. The best filter for this photo is the one called 'Cutout', which you will find under Filter; Artistic. The window contains a number of sliders that you can use to limit the number of colours used. You can also adjust the level of abstraction and the precision of the representation. The higher the level of abstraction, the fewer details are shown.

5 Compare the interim results (top right) with the original photograph at the top of page 14. The edited photograph looks as if it is made up of lots of different pieces of coloured paper. The colours are shown as areas without any shades, and there are not many details.

6 It is also easy to adjust the colours shown: Go to Image; Adjustments and then to Hue/Saturation. Just move the slider to see what happens. There are lots of variables to choose from.

7 After making these easy changes to your photograph on the computer, you will have a greatly simplified template with which to work. All you have to do is transfer it to the stretcher frame and colour in the outlined areas.

Using a photocopier

You can use a photocopier to reduce the number of tones and the detail in your photograph. Copies are inevitably worse in quality than the original, especially if the photocopier is set too light or too dark, but this is actually very helpful in this instance.

After making a copy of a copy, you will have a greatly reduced image. You might find that individual shadow areas blend together too much, or that you lose some details that you wanted to keep. However, this doesn't matter, because you can use opaque white to correct any problems and restore things you might have lost.

For the street scene shown below, the resulting photocopy was combined with the tracing paper technique (page 13). The black-and-white copy makes simplification on the tracing paper much easier.

Tip:

You can also use the photocopier to enlarge the template to the correct size for your final artwork!

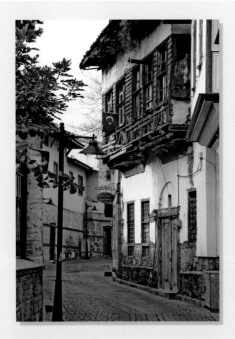
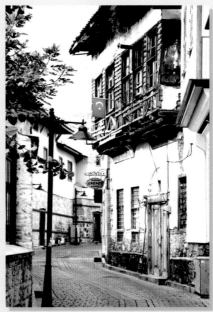
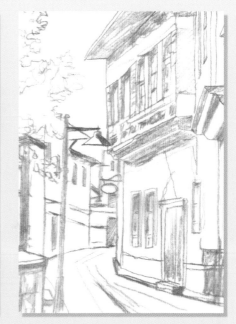

Transferring a preliminary drawing

If you have done a preliminary drawing, you will have to transfer it to the stretcher frame or other painting surface. This is not difficult to do with simple motifs – all you have to do is draw the motif again on the surface. Having done the preliminary drawing, you will have an idea of what you are doing and will already be familiar with the motif. Use harder pencils, because the grey of softer ones will blend messily with the paints later on.

You can easily enlarge the preliminary drawing on a photocopier, then scribble over the back of the copy in pencil. Turn the paper over again and place the scribbled side down on the surface. Finally, follow the lines to trace the motif with a firm pencil. This will transfer the scribbled graphite to the surface.

Tip:

The graphite side of tracing paper marks easily, so it is a good idea to store it in a clear cover or roll it up in newspaper.

Grid method

Another way to transfer an image to the surface is the grid method. You can use it to transfer a motif in any size – even onto the wall of a house or a garage door. Using fine lines, draw an even grid of squares over the preliminary drawing. Next, divide the surface into the same number of squares. Now all you have to do is copy each individual square in turn.

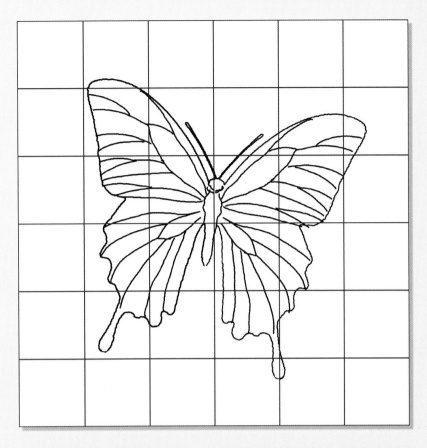

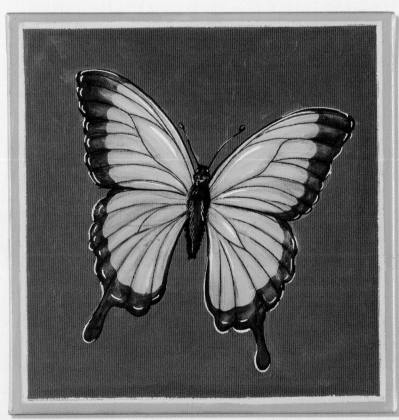

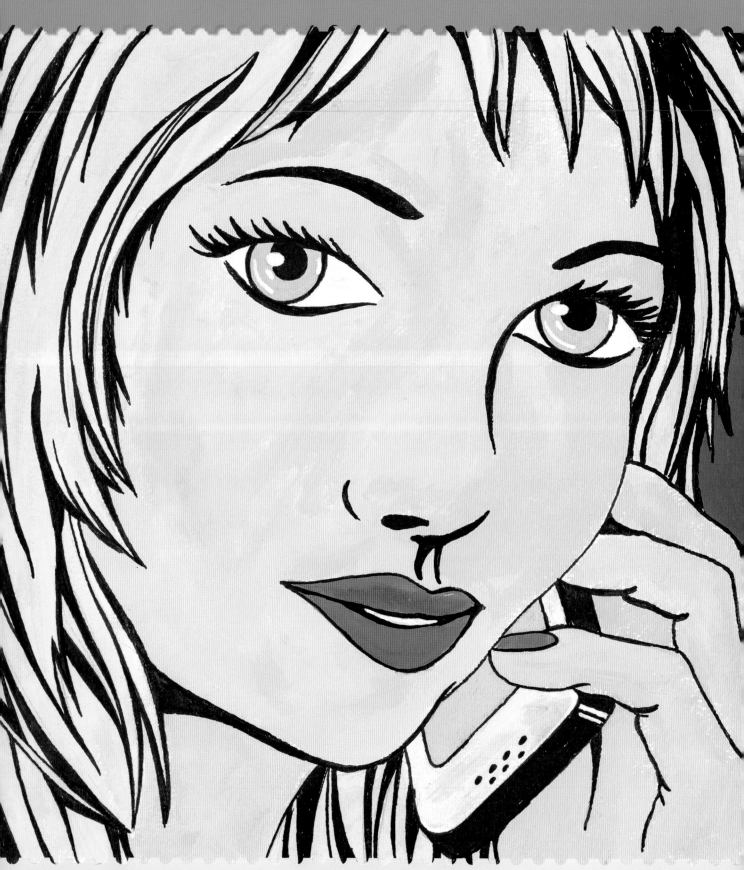

Let's go!

The following pages contain a wide range of Pop Art images and motif suggestions that you can easily copy or follow. They including classics such as the Coke bottle or flowers in the style of Andy Warhol, motifs from the world of brands and cult objects – such as the Cadillac – as well as serial reproductions of people and animals, and motifs in the style of comic books. Enjoy your drawing!

POP ART CLASSICS

Coke Bottle

Like Andy Warhol's can of soup, the Coke bottle is a classic Pop Art motif. Everyone is familiar with the iconic shape of the bottle, which makes it an ideal subject. Follow the insctructions on page 12 to help draw the shape of the bottle.

You can choose an existing brand of your choice, or use your own modified version, as shown here. Why not try creating your own brand?

Materials

* Orange-coloured cardboard, 42 x 30cm (16½ × 11¾in)
* Acrylic paint: blue
* Paintbrush: size 10 flat
* Black marker pen
* Pencil
* Drawing paper

1 Draw the outline of the Coke bottle, making sure that both sides are symmetrical. You can use construction lines to help check that the bottle is straight.

2 Draw in the reflections in pencil and decide which areas to colour. The hatching makes it easier to see which areas will be coloured and which will not.

3 Use a hard pencil to transfer the drawing to the coloured cardboard, and carefully colour the hatched areas in blue.

4 Finally, draw along the outlines of the bottle and the logo in black marker. You will find it easier to draw the rounded lines if you turn the paper slightly as required.

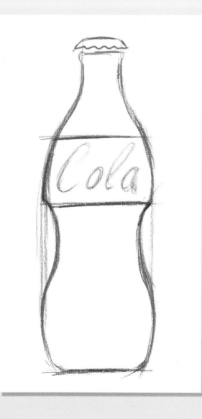

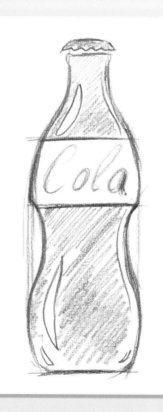

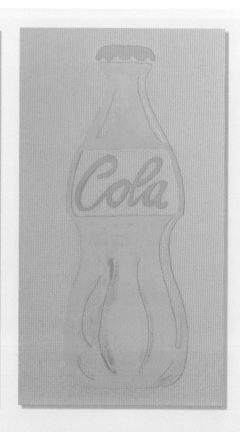

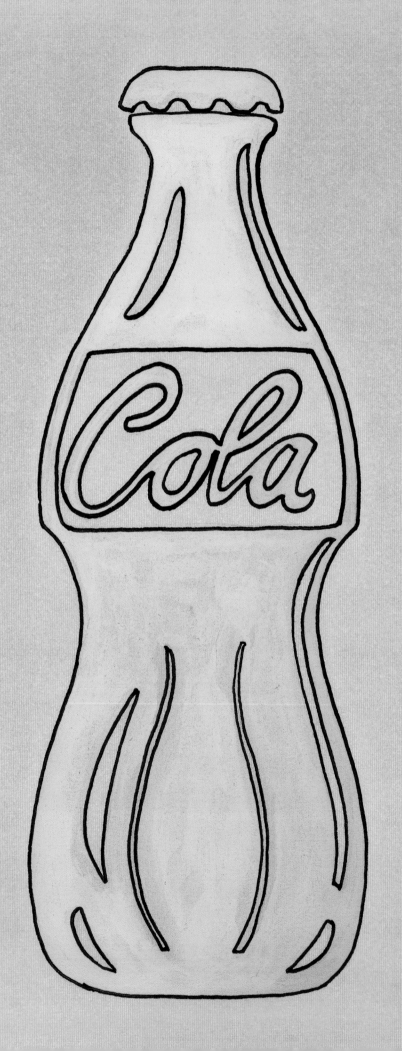

Pop Art Logo

As explained earlier, symbols, logos and trademarks from branded goods and advertising are often used in Pop Art. Company logos are usually simplified to poster-like symbols or even just the company name. We are doing just that here, converting the words 'Pop Art' into a graphic image. Of course, you can also apply the principles to a different name or logo.

Materials

- White artist's board 30 x 42cm (11¾ × 16½in)
- Acrylic paint: white, orange, pea green, magenta, cyan and lilac
- Paintbrushes: size 4 and 10 round
- Pencil and ruler
- Tracing paper
- Letter templates (or computer and printer)

1 You have two options with the letters: either design your own and create them yourself or, if you think this might be too difficult, you can do it on a computer.

For the latter option, print the letters in the desired size and font, and trace around the outlines on tracing paper. You can then go over the lines in soft pencil on the back. This does not work so well with a hard pencil because the results are not clear enough. If you then turn the tracing paper over on your painting base, you can go over the lines again – and you have a tracing that you can rub out. You can save a step if you print the logo out in a mirror image, as then you will only have to go over the letter twice.

2 Use a pencil and ruler to carefully draw out a grid, and transfer the letters into the individual squares, leaving a small gap between the letter and the edge of the square. Next carefully fill in each letter and background with colours of your choice. The overall effect is more harmonious if you repeat some of the shades. Adding white softens and mutes the colours.

3 If you like the subtle effect achieved with the first layer of colour, then your picture is done.

4 However, if you want a richer and more even result, then simply repeat step 2 to strengthen the colours.

Flower Collage

This collage was inspired by Andy Warhol's famous floral motifs, and it is a delight to reproduce. The textured background is the result of a simple movement that even beginners can achieve with ease.

The flowers are glued to the base some distance apart, which creates an interesting effect and makes them appear to be floating over the meadow. A matching frame completes and enhances the overall impression.

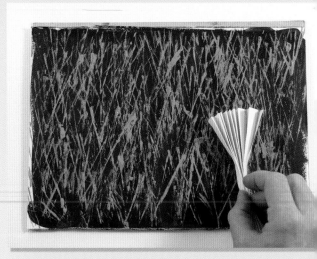

Materials

* Black cardboard and white artist's board
* Acrylic paint: black, leaf green, cadmium red, orange, Indian yellow, lavender and light blue
* Paintbrush: size 10 flat
* Flat palette
* Black marker pen
* Pencil, scissors
* Drawing paper and corrugated cardboard
* Glue (or adhesive tape)

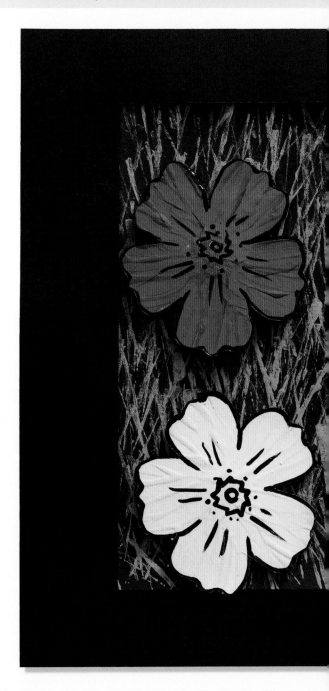

1 Colour one piece of artist's board black. When it is dry, fold a piece of drawing paper into a concertina. Spread a little green paint on the palette. Dip the folded paper in it and dab blades of grass on the board.

2 Draw the simple flowers on another piece of artist's board and paint them thickly, working from the inside to the outside. The thickness of the paint creates a flower-like texture. The artist's board you use should not be too thin, but should also be easy to cut with scissors.

3 Cut out the flowers and go over the contours in black marker pen. Stick small pieces of corrugated cardboard to the back as spacers (you might want to use two layers of cardboard, depending on the thickness of the material and the desired effect) and then stick on the flowers.

4 To finish, stick black cardboard around the edges as a frame.

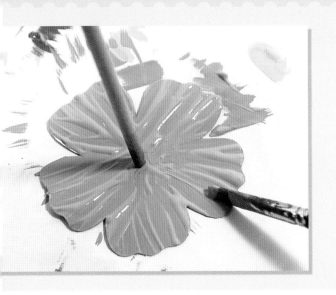

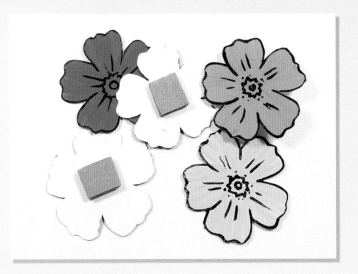

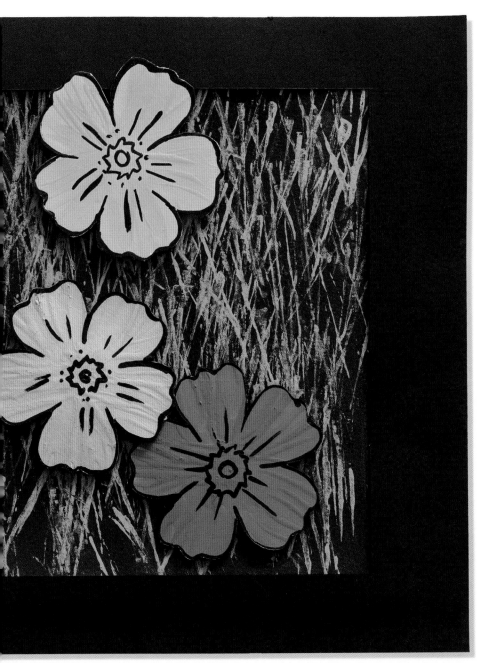

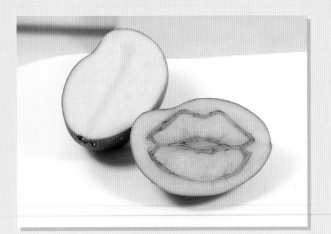

Lips

You probably remember this painting technique from when you were a child! Potato printing is still popular in schools today. It is usually used to print simple shapes such as hearts and stars on fabric or paper. However, with a little practice, you can also use it for other motifs such as animals or lips, as seen here.

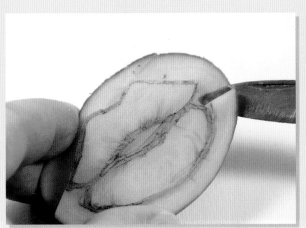

Materials

- Cardboard in four colours (or artist's board to paint over), each 15 x 15cm (6 × 6in)
- Acrylic paint: chrome yellow, cadmium red, orange, permanent green, cyan and lilac
- Roller for linoleum printing or a spatula
- Flat palette or a piece of cardboard
- Potato
- Kitchen knife
- Watercolour pencil

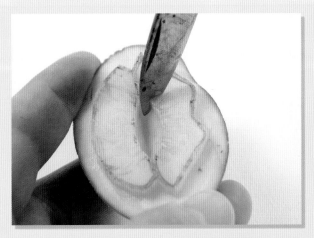

1 Cut the potato in half and use the watercolour pencil to lightly draw the outlines of a pair of lips onto the cut surface. Graphite pencil lines would be very difficult to see, but the moisture in the potato will slightly loosen the colour in a watercolour pencil. If you draw the lips on a sheet of paper first, you will find it much easier to copy them onto the potato.

2 First run the blade of the kitchen knife over the outlines, then cut the excess potato away. You only need to go down a few millimetres.

3 Make a few additional cuts into the printing surface to give the lips some texture.

4 Roll a little paint over the palette. You can also use a spatula to spread a thin layer of paint. Press the potato stamp into the colour, and then you can get started by pressing the stamp down onto the surface. The only way to determine the amount of paint required for a good print is to try it out. It is often less than you might think.

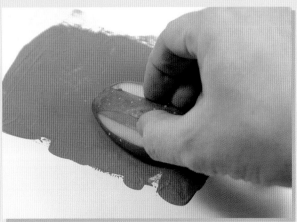

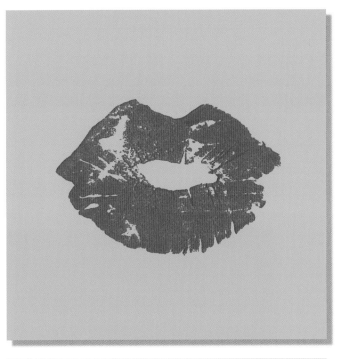

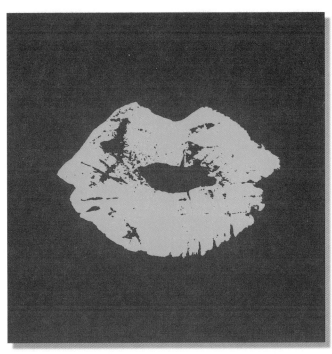

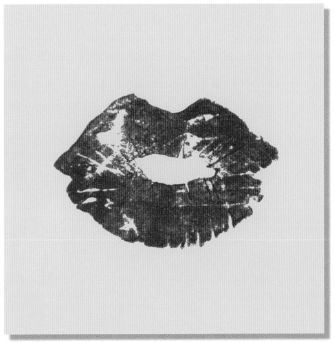

Tip:
If you cut a little handle
into the back of the potato
you will find the stamp
easier to handle.

Zip

A small, everyday utility item is emphasised and oversized to make it an art object. A number of Pop Artists – Claes Oldenburg, for instance – have used this technique.

You can do the preliminary drawing from a zip if you happen to have one to hand, or else use the image here. The colour combination used in this example – red, white and black – is an advertising classic, and many products and newspapers used this eye-catching colour combination.

Materials

* Stretcher frame, 50 × 70cm (19¾ × 27½in)
* Acrylic paint: madder red, cadmium red, black, white and cerulean blue
* Paintbrushes: size 8 flat and size 16 flat
* Pencil

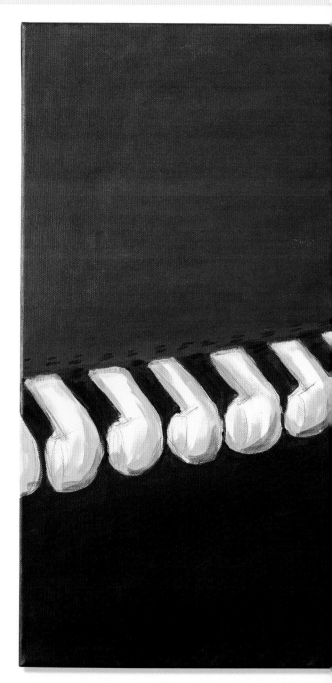

1 Sketch out the basic shapes on the canvas using the pencil. You might find it helpful to look for shapes that can be simplified when you draw them. Where can you see lines, and circles, in the shape of the zip?

2 Cover the picture with an initial layer of paint, leaving only the lightest areas uncovered. The red is a mixture of madder red and cadmium red. The grey is mixed from cerulean blue, black and white. (A grey that is mixed only from black and white comes across as cold and artificial. The addition of a tiny amount of blue gives the impression of metal.)

3 Repeat with a second layer to improve the coverage. Mix black with a little cerulean blue and paint the sides that are out of the light.

4 Create depth by adding a slight shadow on the red fabric, and also on parts of the zip. Make sure it is clear where the rounded articulated part disappears inside the opening of the slider.

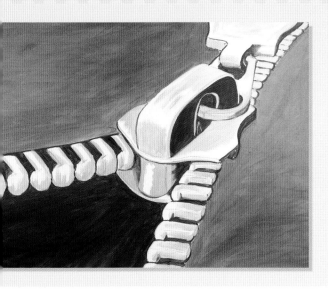

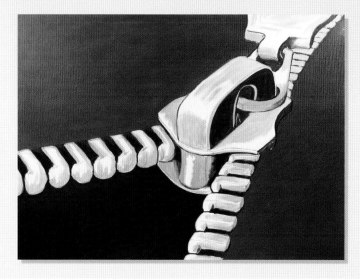

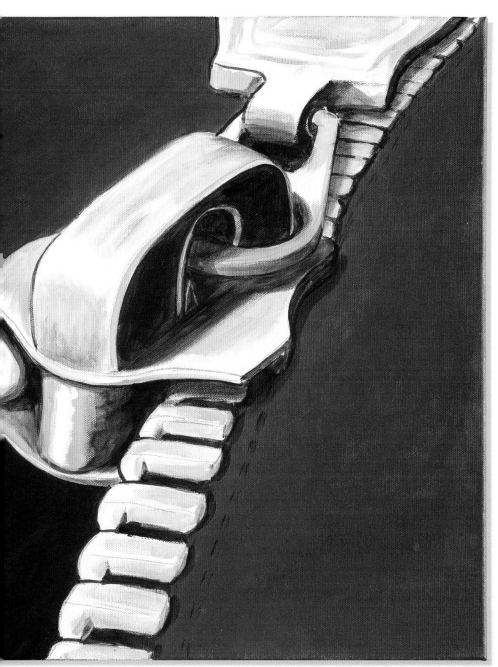

Tip:
*Look at the photograph
or your preliminary
drawing through a paper
frame to find the most
exciting section.*

BRANDS AND CULT OBJECTS

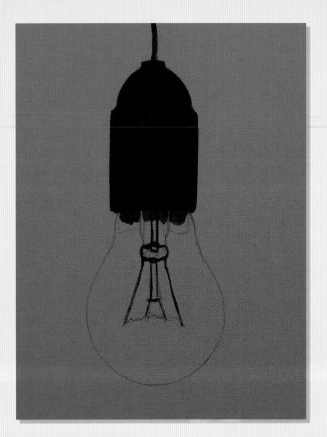

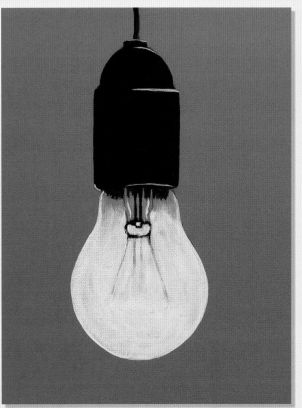

Light Bulb

The light bulb is an object familiar to anyone who has ever moved house. So familiar is this basic, typical shape – often the only light source in a room – that it becomes unnoticed. By drawing attention to it, we create an interesting picture.

Materials
* Acrylic artist's paper 42 x 30cm (16½ × 11¾in)
* Acrylic paint: titanium white, blue, green, orange, purple and black
* Paintbrushes: size 8 flat and size 12 flat
* Fine detail brush
* Black marker pen or fineliner
* Pencil

1 Prime the four rectangles. If you have a traditional light bulb and base to hand, you can place it in front of you and draw it. Make sure that you copy the details and the shape of the base (screw or bayonet) and the bulb exactly, and that they are completely symmetrical. By contrast, the cable is slightly rounded, which makes it look quite realistic. Next, colour the base and cable in black, and paint the inside details of the bulb with the fine detail brush. You can use a marker pen or fineliner for these details if you prefer.

2 Paint the bulb itself in white. Leave a small area free at the transition to the base so the background can be seen through the transparent glass. The addition of fine white lines to the edges of the base is enough to give it the typical shape.

3 To finish the lightbulb, draw fine lines over the filament and other inside parts. Repeat on the other four differently coloured versions, then place them together.

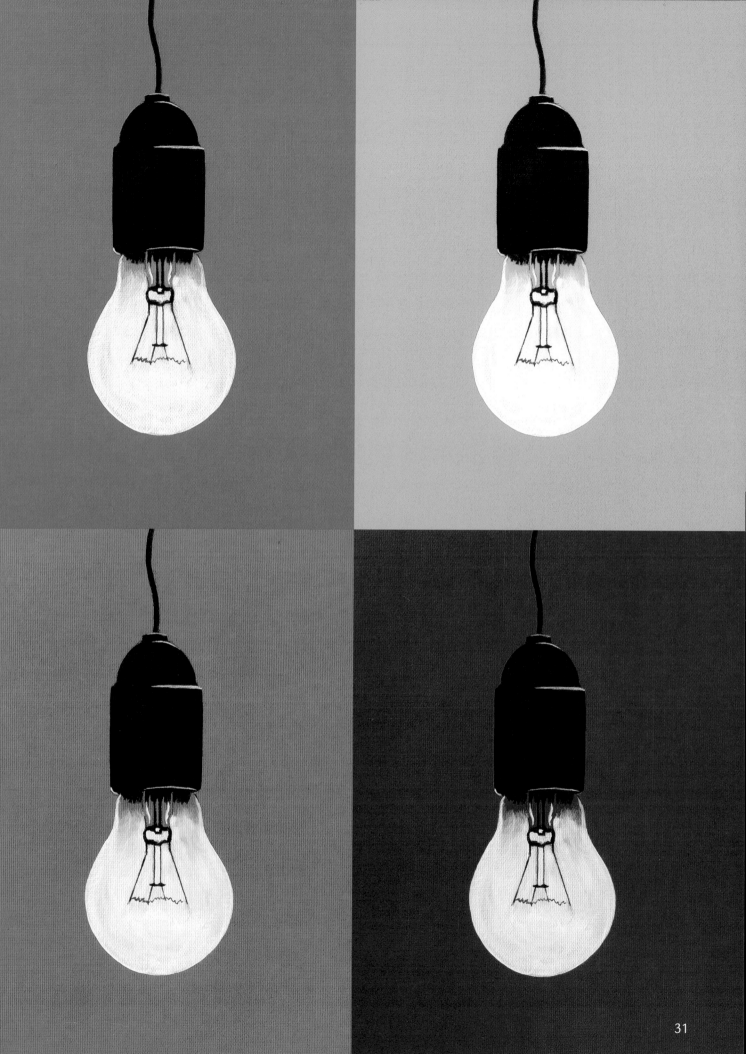

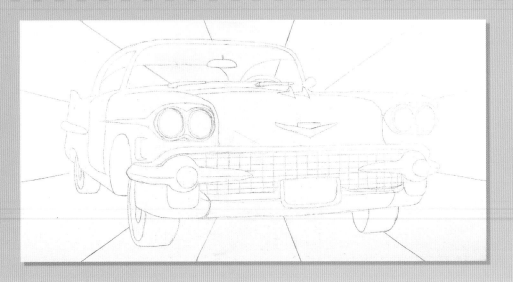

Cadillac

This kitsch pink cadillac is a cult car. Just looking at the distinctive lines of a '58 Eldorado is enough to transport you to a bygone era – doesn't it remind you of stars like Elvis and Marilyn Monroe? The bright background rays in contrasting colours add further emphasis.

Materials

* Stretcher frame, 40 × 80cm (15¾ × 31½in)
* Acrylic paint: titanium white, cadmium yellow, cobalt, cyan, magenta, cadmium red, pea green and black
* Paintbrushes: size 8 flat and size 12 flat
* Fine detail brush or black marker pen
* Strips of cardboard or a spatula
* Ruler and pencil

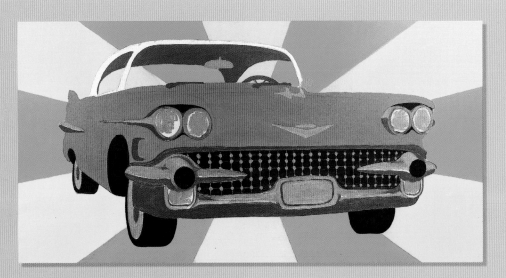
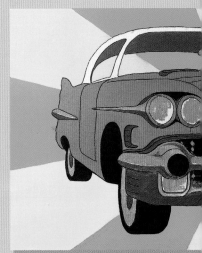

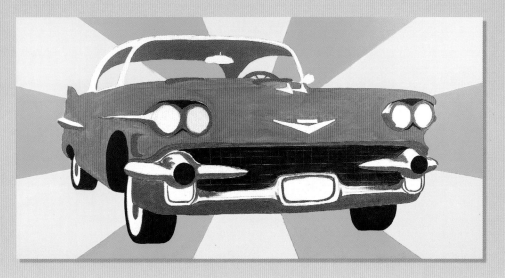

1 Transfer the template to the stretcher frame. Carefully copy the background rays – since the extreme landscape format would make equally-sized rays look out of proportion, they are stretched towards the sides to achieve visual balance.

2 Mix yellow and pea green with a little white, and paint the wedge-shaped rays. Hold a spatula or stiff piece of cardboard at an angle against the border between yellow and green and move the brush along it for nice, straight lines.

3 Mix magenta, cadmium red and white together to make pink, and paint the body of the car. Paint the wheel arches, tyres and radiator grille in black. Use a pointed brush handle and ruler to make lines in the paint of the grille while it is still damp. Colour the darker areas of the chrome parts in a dark grey.

4 Colour the shiny chrome parts in a lighter shade of grey. Combine black and white with a little magenta to make the right shade.

5 Now it's back to the contouring – use the marker pen or a thin brush to draw (or paint) fine lines around the individual components.

6 Brighten the lamps with white, and add white reflections to the chrome parts. Adding a few small light reflections to the body will help to lift it and add a shine.

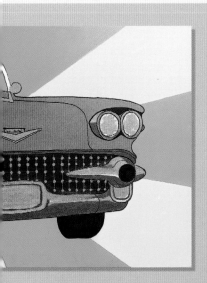

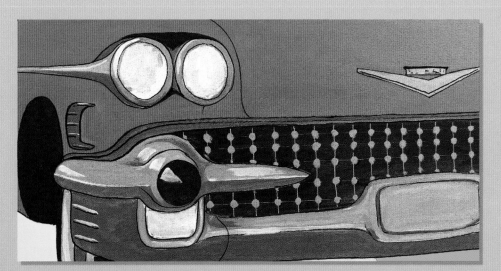

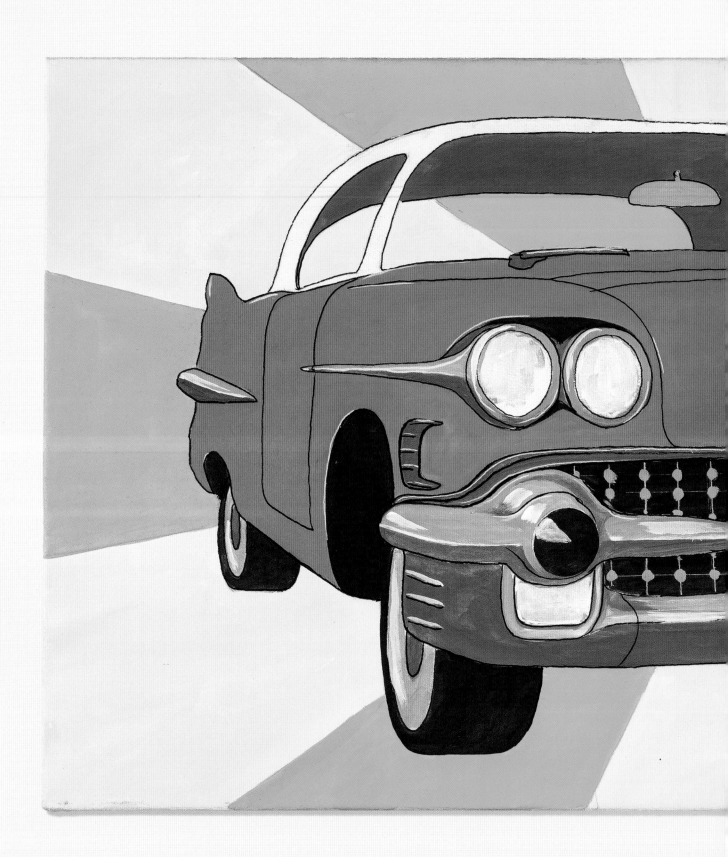

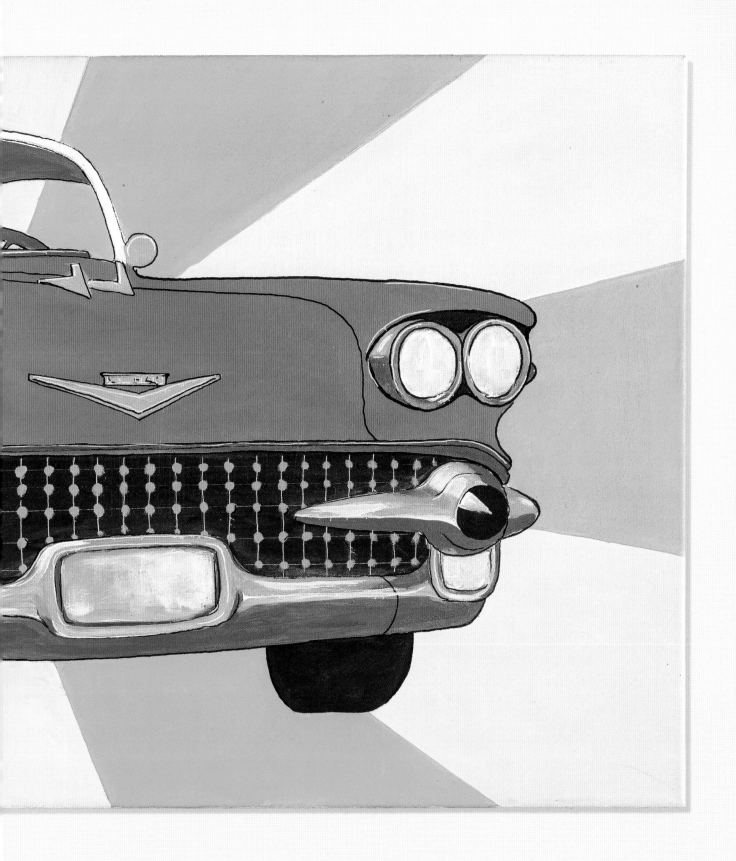

Sneakers

One Pop Art process that you are probably familiar with is the serial reproduction of an image, with variety added through the choice of colours. The best known example of this technique is probably Andy Warhol's *Marilyn Monroe* series, for which he used screen printing. We're going to mimic the process by hand and paint the same simplified motif four times.

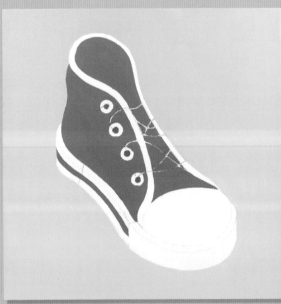

Materials
* Four stretcher frames, each 30 × 30cm (11¾ × 11¾in)
* Acrylic paint: white, pea green, orange, scarlet, lilac, cerulean blue and turquoise
* Paintbrush: size 10 round
* Fine detail brush or black marker pen
* Pencil

1 This project starts with a simple pencil drawing on the canvas. Make sure you clearly distinguish the shoe elements – the upper fabric edge, laces, aglets, sole, and toe cap, for example – from each other.

2 Next, choose the colour areas. Tint the colours with a little white for a pastel effect. This will also help to improve the coverage of the pencil lines and the white background. Watch out for the white areas.

3 Allow the paint to dry completely before continuing. If you start contouring too soon, the pen will not work well, and could also be blocked by the paint. Go over all the contours in black pen. The laces are just simple lines.

4 Repeat the process with different colours. The particular charm of this technique is the result of the combination of colours. I used four small square stretcher frames here, each with the same image in different pastel hues.

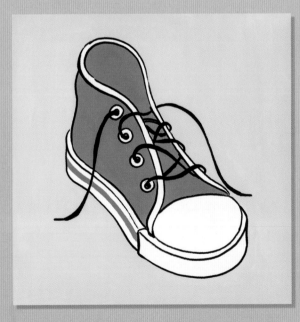

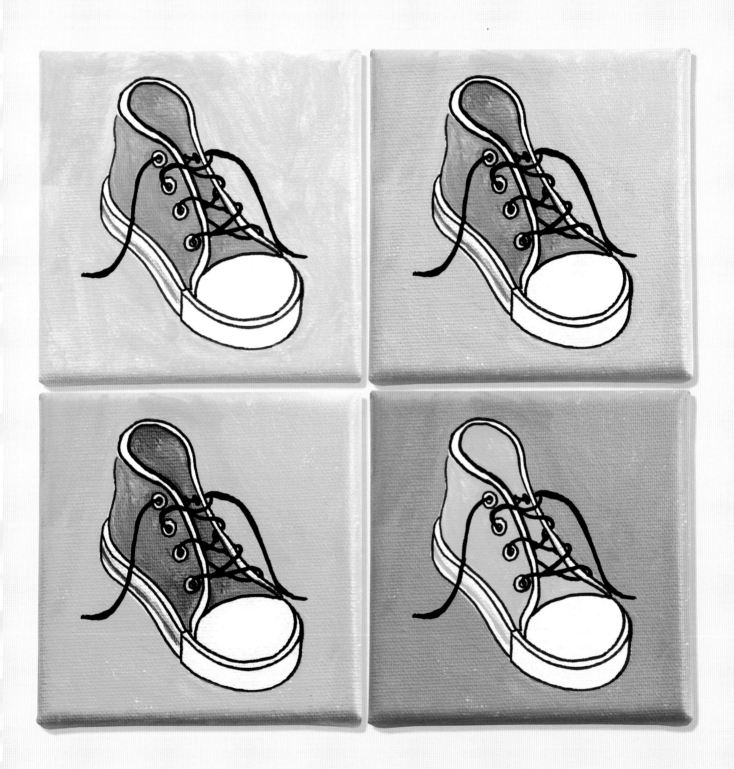

Tip:

Try your colour combinations on a sheet of paper first, perhaps as large dots. This will save you from having to make corrections.

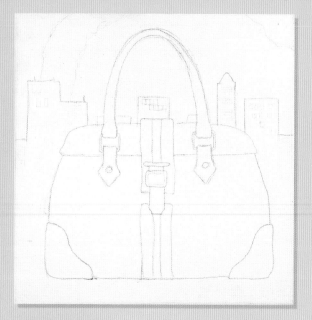

Handbag

Bags, bags, bags – whether a backpack for a hike, or a designer bag for a stroll through the city, for many of us, they are an essential part of daily life. This project sets a classic handbag against an urban background.

Materials

- ✦ Square stretcher frame, 40 × 40cm (15¾ × 15¾in)
- ✦ Acrylic paint: black, white, magenta, cadmium red, orange, yellow and cobalt
- ✦ Paintbrush: size 12 flat, size 4 round
- ✦ Fine detail brush or black marker pen
- ✦ Pencil

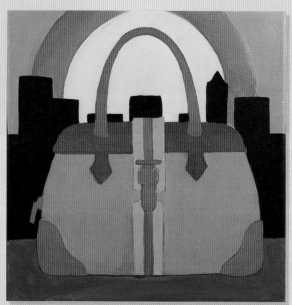

1 Design a bag to your own taste or copy your favourite from your collection. Add a simple skyline and a couple of arches to the background. Then transfer this template to the stretcher frame using a pencil.

2 Paint the various areas of the bag and the background. Mix together blue and white for light blue. Add a little blue to the black to lift it a little. Repeat this process so the colours cover the surface well. You can also adjust the colour mix if necessary – or simply to your own taste.

3 Use the flat brush to colour the strip at the top of the bag, then mix some yellow and white together and use the small round brush to paint in the lights of the skyline along with the dots and buckles on the bag.

4 To finish, carefully outline all the elements using the marker pen.

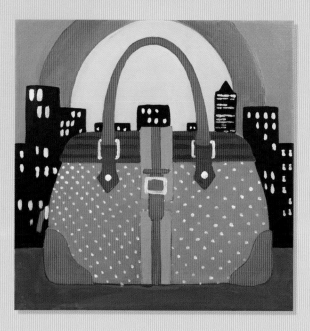

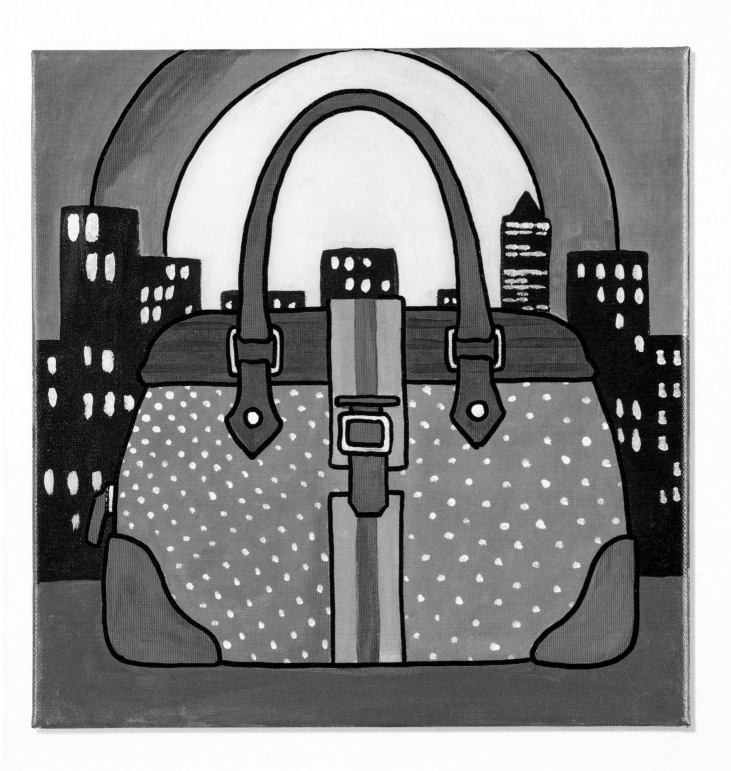

QR Code

Pop Art isn't stuck in the past. Here is a contemporary motif from the digital world. Today, advertisements always seem to have a QR code. This coloured version is created without a brush. Rather than being painted, it is 'taped' – using ordinary insulating tape.

Materials

* White cardboard
* Insulating tape: black, red, yellow and blue
* Ruler
* Pencil
* Glass sheet
* Craft knife

1 Enter your chosen text into an online QR code generator. In this example, the text simply reads 'POPART'. Print the code out on a printer and increase the size until one pixel square in the image is the same width as the adhesive tape, in this instance 15mm (¾in).

2 Use the pencil and ruler to draw a grid with the same dimensions as the code – 21 x 21 lines in this example – on the white cardboard. (If you are using a longer text, the code will become proportionally finer.) Put the sheet of glass on the grid and stick on the strips of black tape. Trim the strips as required using the craft knife.

3 Pull the tape off the glass and stick each piece onto the cardboard using the grid for reference. If necessary, stick two strips over some areas in order to avoid unattractive flashes between the strips.

4 You will probably have to do a few small corrections at the end. It's a good idea to check in advance and make sure you can pull off the tape once you have stuck it on without damaging the cardboard.

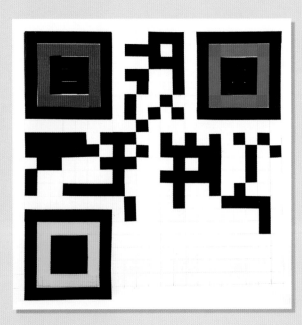

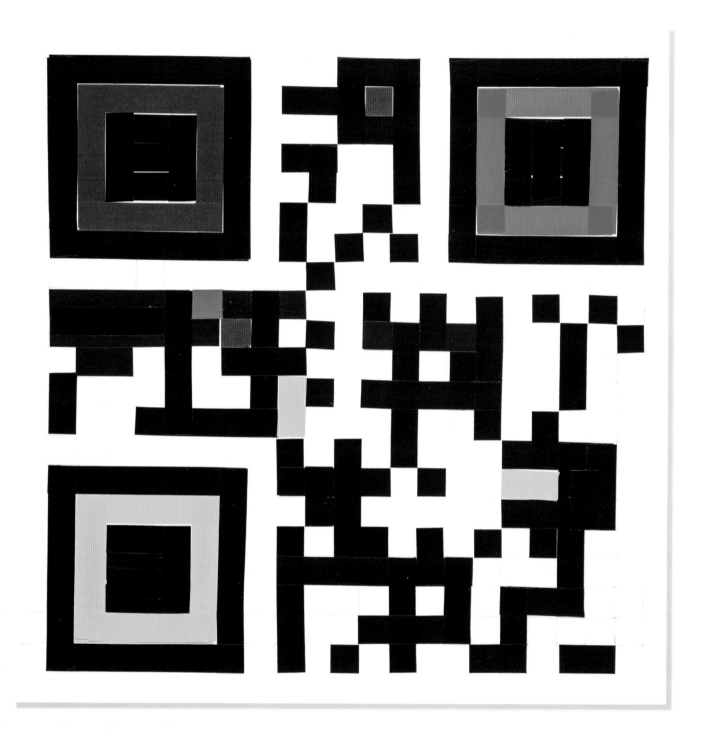

Tip:
*You can also create this
motif in acrylic paint or
with coloured felt pens.*

Cuckoo Clock

Bright colours instead of dark wood: cuckoo clocks in loud colours aren't only popular in Switzerland. A new Pop Art trend is all about playfully interpreting traditional motifs. You can also decorate your cuckoo clock with different figures and elements – there are no limits on what you can add when using a little imagination.

Materials

* Stretcher frame, 30 × 40cm (11¾ × 15¾in)
* Acrylic paint: brilliant pink, cyan, mixing white, pea green, cadmium yellow and orange
* Paintbrushes: size 8 round and size 14 round
* Black and white marker pens (or a fine detail brush)
* Black paint or charcoal pencil
* Smooth masking tape
* Pencil

1 Start by creating a preliminary drawing. Draw the main shapes clearly in pencil. Next, use a thick coloured pencil to highlight the final contours. Transfer the preliminary drawing to the canvas, then add vertical strips of masking tape. The gaps between the strips must be the same as the width of the tape. Paint the background with brilliant pink, omitting the area of the cuckoo clock.

2 Next, colour in the clock using bright, slightly pastel colours. Tint the colours with white – the colours will be livelier if you use mixing white instead of a covering white such as titanium white. Choose colours that will make adjoining elements of the picture stand out from each other.

3 Allow the paint to dry well, then stick more vertical strips of masking tape onto the picture. Combine pea green and cyan with a little white to make a light turquoise mix. Paint the background in this colour, then remove the masking tape strips. This is important, because moist paint will make the tape start to wrinkle, which could allow the paint to run into the pink strips.

4 Outline all of the coloured areas with black. Add more lines to hint at a wooden texture and add shape to the elements, such as the blue pine tree. A few more white lines on the coloured areas will add a sheen to the clock and lift it from the background.

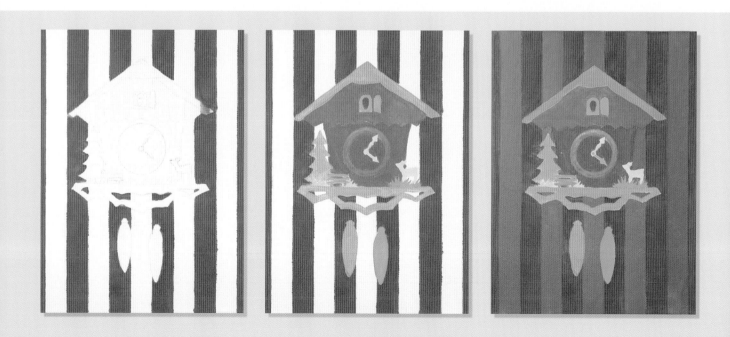

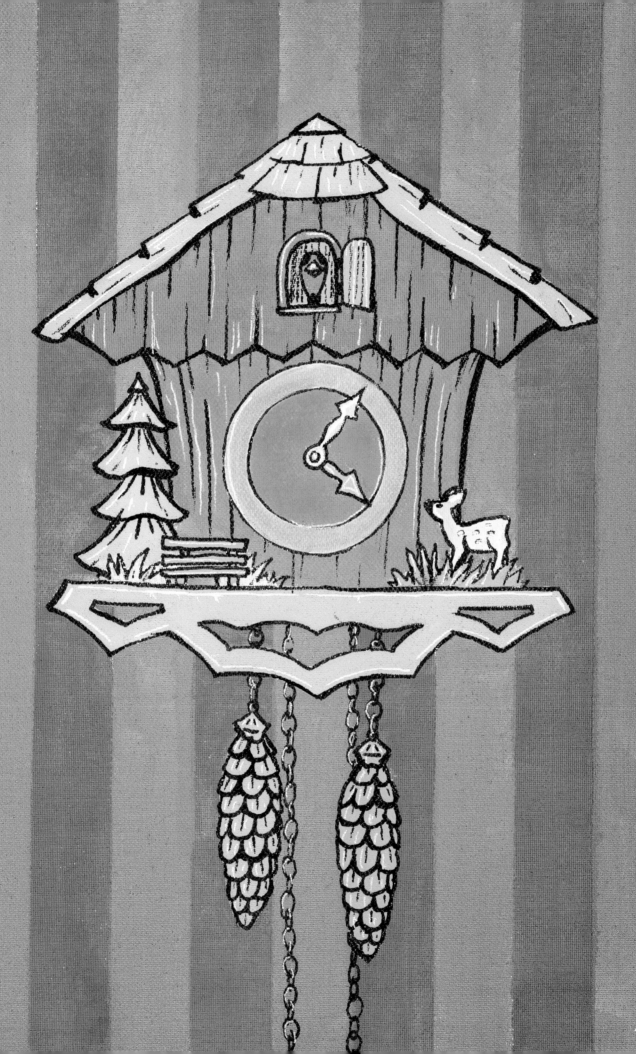

Beethoven

The motto here is: Classic meets Pop. This portrait of the famous German composer is reproduced here in bright colours. You can, of course, use your favourite musician or film star instead – all you need is a photograph. Copy it to the desired size, or print it out and trace it.

If you are not confident about simplifying or tracing it, have another look at the instructions on pages 12–13, for a reminder of these techniques.

Materials
* Stretcher frame, 30 × 40 cm (11¾ × 15¾in)
* Acrylic paint: Indian yellow, pea green, cadmium red, magenta and black
* Paintbrushes: size 8 flat and size 14 flat
* Painting knife
* Bristle brush
* Pencil

1 Sketch the background and the outline of the figure in very roughly using the pencil, then paint in the main areas with flat colour. It does not matter if the drawing doesn't match the coloured areas. In fact, this helps to make the end product even more special. You can use a painting spatula instead of the brush, which makes it easier to achieve this slightly 'unfinished' effect. For instance, the black edge on the left was worked with a spatula. This also achieves clear boundaries between the coloured areas.

2 Once the paint is dry, trace the preliminary drawing onto the stretcher frame in pencil. Look out for the darkest areas of the picture. These are finished in black later on.

3 Keep the details on the clothing very dark. Only a few eye-catching elements, such as the collar, are highlighted by being left in bright colour.

4 With the clothing complete, it's time for the hair. Gather it in strands, and observe the direction and wavy structure when painting.

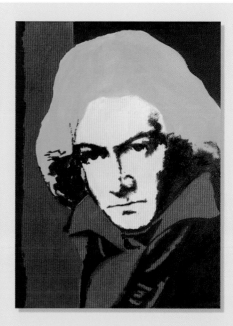

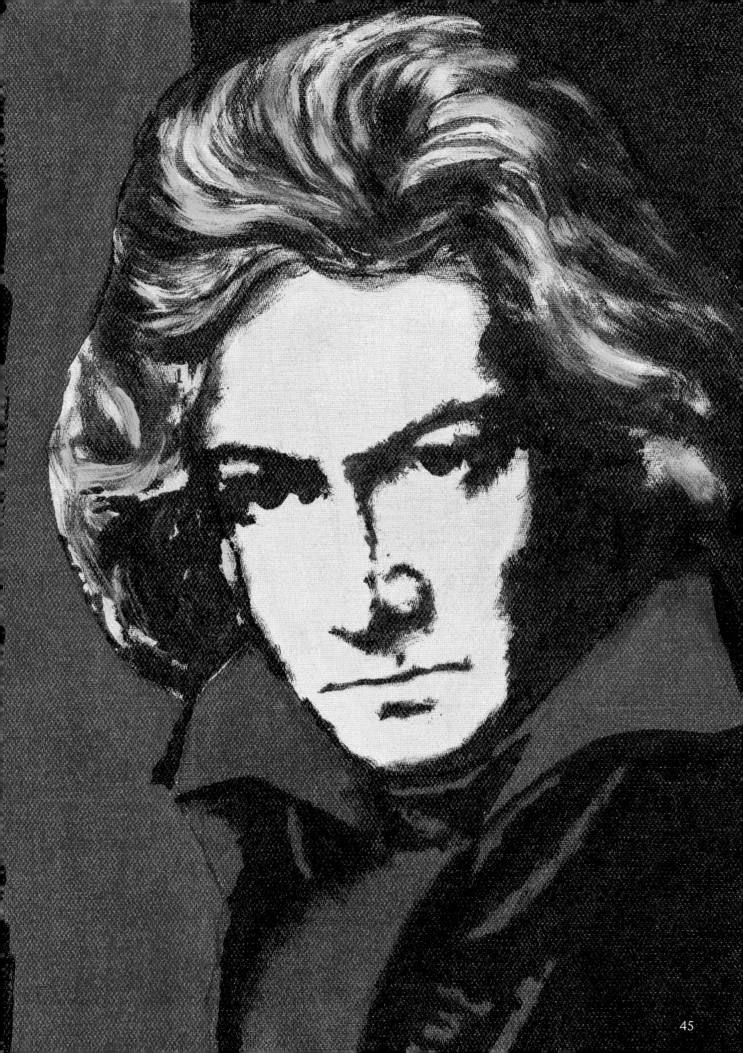

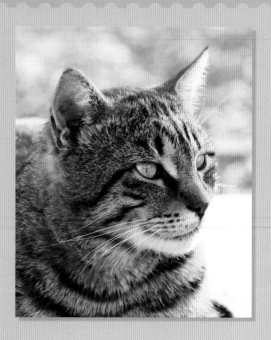

Cat

This simplified version of a cat allows you to paint the motif several times. Varying the colour combinations creates an exciting effect. The serial reproduction of a motif is based on Andy Warhol's typical Pop Art works. If you trace the picture from a photograph, you can use the tracing paper several times. Just colour over the back again.

Materials

* Acrylic paper: four piecces, each 30 × 40cm (11¾ × 15¾in)
* Acrylic paint: cerulean blue, royal blue, white, black, cadmium yellow, pea green, cadmium red, magenta and lilac
* Paintbrushes: size 12 flat and size 4 round
* Pencil
* Tracing paper
* Copier or ruler (for the grid method)

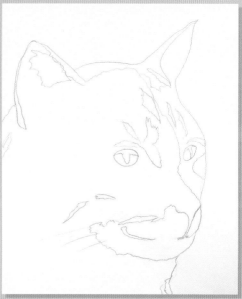

1 Pick a favourite photograph of your cat and trace it using tracing paper.

2 Enlarge the preliminary drawing to the desired size on a photocopier, and transfer it to the four pieces of acrylic paper. If you prefer, you can use the grid method to transfer the picture instead (see page 17).

3 Apply the background colour with the flat brush, and then start to colour the midtone areas of the cat with the detail brush. The colour combination in the example to the left consists of a mix of cerulean blue and royal blue, tinted with a little white.

4 Allow the paint to dry for a short while, then add the darker areas. Mix black and royal blue for the dark shade of indigo. Proceed with care for the whiskers, and paint them carefully in light blue using the detail brush. If you have reduced your motif to only a few colours (perhaps just several shades of one particular colour like the blue used here), it will not take long to paint the other pictures in other colourways and combinations. Colour combinations that don't really go together also have their own charm!

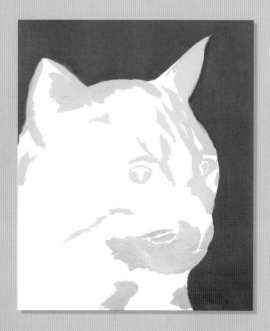

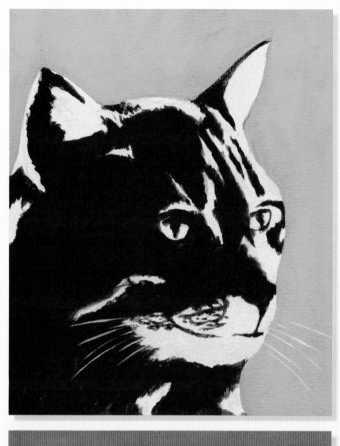
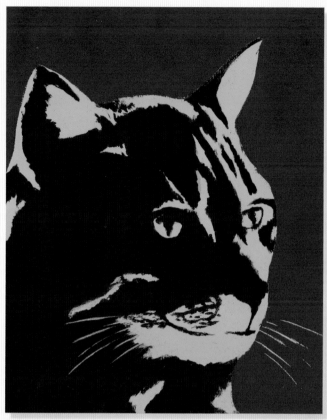
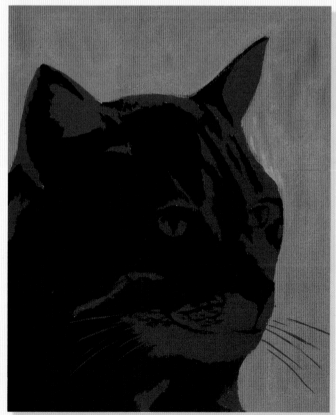
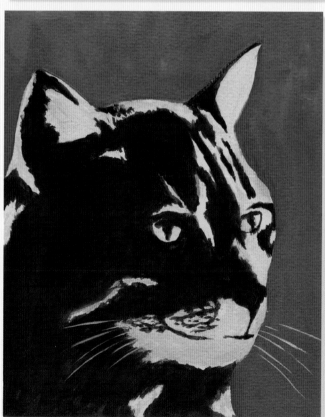

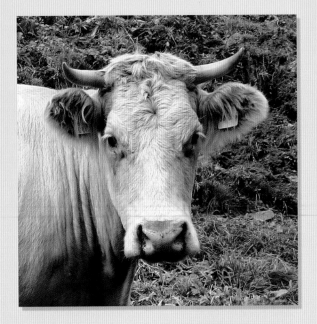

Cow

An iconic farm animal is the motif here – the cow is a typical symbol of country life, and has star potential! The distorted and exaggerated colours are typical of Pop Art. In fact, using an unusual approach to colour is a good way to add life to an image.

A computer is used as a painting tool here, because editing programs offer lots of methods for picture distortion. Some examples include the commands 'Tonal separation' and 'Coloured paper collage'. The confusing colours that the computer usually produces are easily removed by changing the picture to shades of grey. With a little practice, you will soon be able to do this with your favourite photograph (see pages 14–15). Shown against a red background, the monochrome cow looks fresh and modern.

Materials

* Square stretcher frame, 30 × 30cm (11¾ × 11¾in)
* Acrylic paint: white, black and cadmium red
* Paintbrushes: size 12 round
* Pencil
* Computer and printer

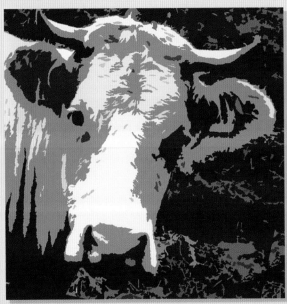

1 Select your favourite photograph and import it into your editing program.

2 Choose an interesting section of your photograph. A square is a good format for the cow. Use the graphics program to reduce the photo, and the command 'Tonal separation' to reduce it to three shades. Convert the file into a black-and-white image.

3 Print out the picture and transfer it to the canvas. Paint the background in red, and the cow in black and one shade each of medium and light grey. Even if you don't keep exactly to the computer original, you will find it extremely useful.

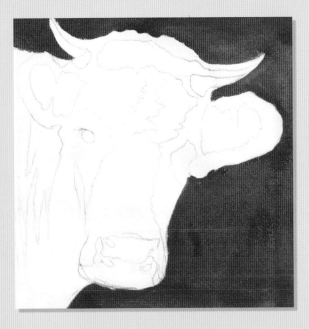

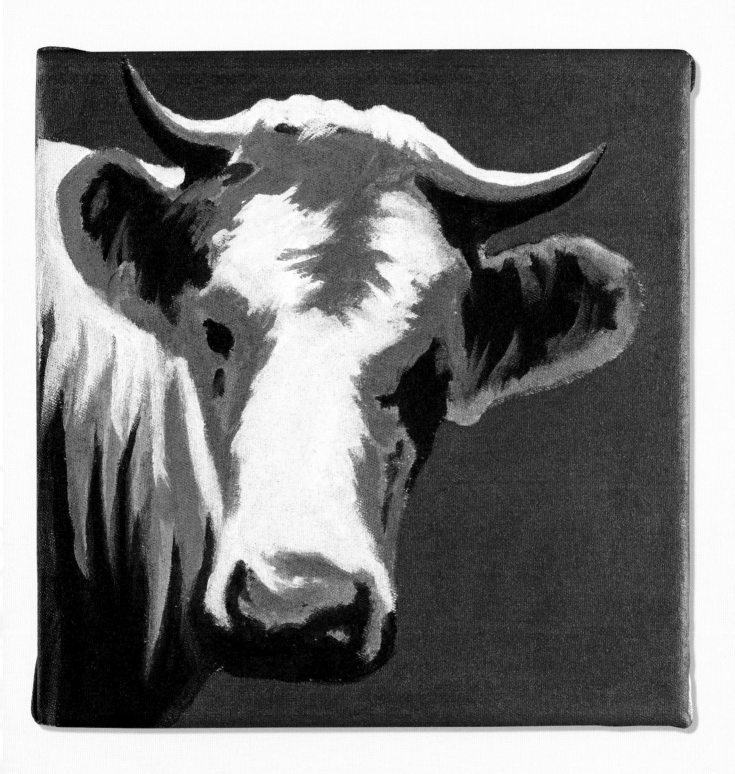

Portrait

Why not immortalise your family or friends in a Pop Art picture? All you need is a suitable photograph and an editing program. The process is explained on pages 14–15.

1 Convert a photograph into shades of grey on a computer, and transfer this to artist's board thinly in pencil. Pick out the hair and shadowy parts of the face in a grey-blue mix of paint.

2 Combine blue, black and white to create two different tones, and use them to colour the shadowy areas. Painting with a reduced colour palette is much easier than trying to reproduce realistic skin tones.

3 Colour the face in Indian yellow, and do the same with the sun in the background. Colour the remainder of the background in a mixture of red and orange.

Materials

* Artist's board, 30 × 40 cm (11¾ × 15¾in)
* Acrylic paint: Indian yellow, orange, cadmium red, Prussian blue, white and black
* Paintbrush: size 10 flat
* Pencil
* Computer and printer

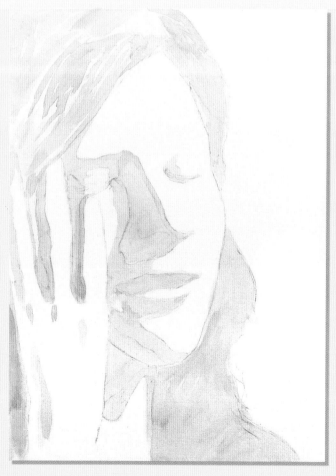

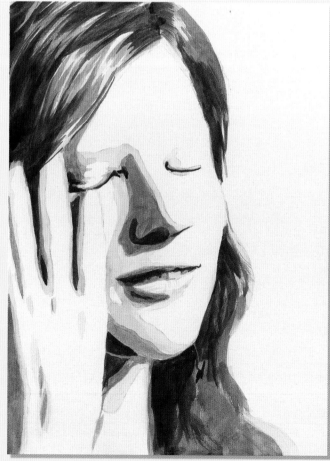

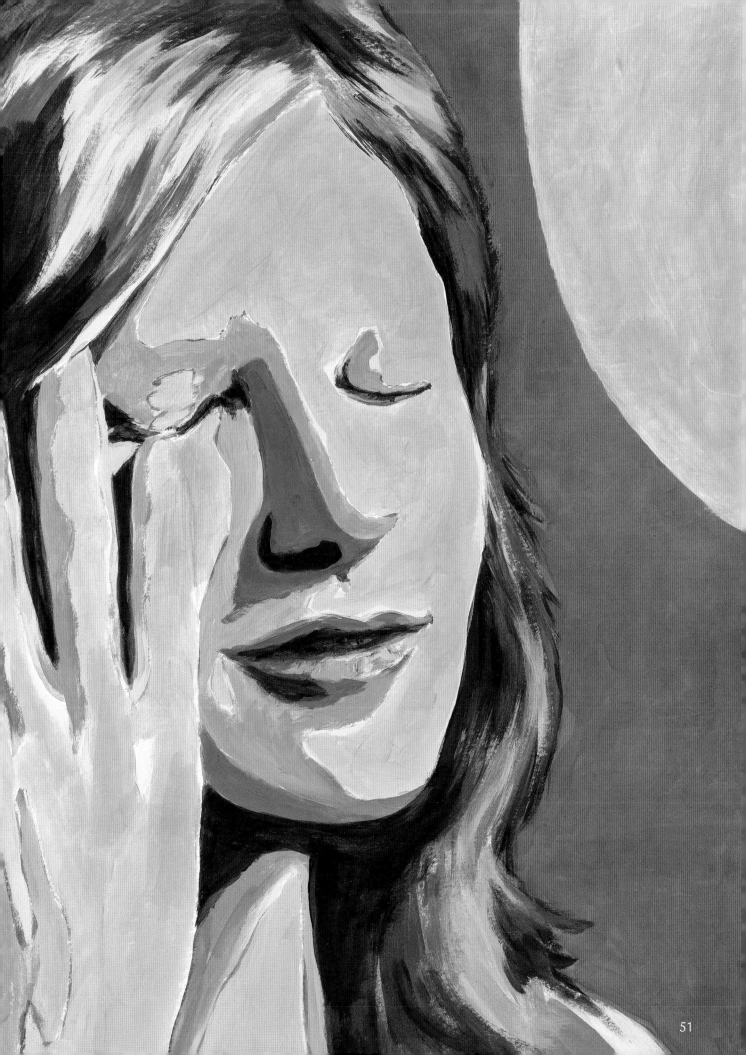

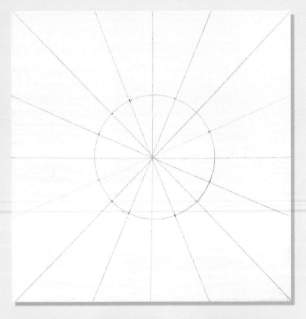

Rabbit

It's fun and easy to turn this popular pet into a glowing Pop Art icon – let's go!

Materials

* Square stretcher frame, 30 × 30cm (11¾ × 11¾in)
* Acrylic paint: titanium white, cadmium yellow, cobalt blue, cyan, orange, pea green and black
* Paintbrush: size 12 flat
* Old brush with thin bristles
* Ruler or batten
* Round object (such as a cup)
* Pencil and eraser

1 To make the background rays symmetrical, draw two diagonal lines that intersect at the middle of the stretcher frame. Next, draw around the round object to make a circle around the intersection. Add small marks on the resulting round segments to halve or quarter them (depending on how many rays you want), then use the ruler to draw a line through these dots to join them and create the rays.

2 Draw the rabbit, then use the eraser to rub out as much of the lines as you can. Paint the rays in two alternating colours, adding a little white to each colour so they are not too dark and to improve the coverage.

3 Use the old brush to paint a few shadowy areas in black on the face and ears, nose and eye. Add a little blue so the black is not too strong. The sparseness of the bristles will make the dark areas a little lighter and more irregular.

4 Add the shadowy areas on the rabbit's body, such as the belly, making sure that the black brush strokes are not too solid and flat. To finish, place the painting on a flat surface, (otherwise the thin paint will run), then add a few patches of very dilute orange, yellow and green.

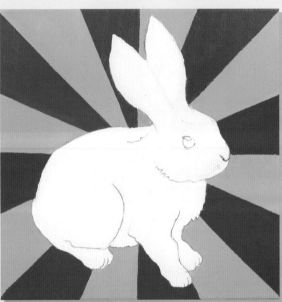

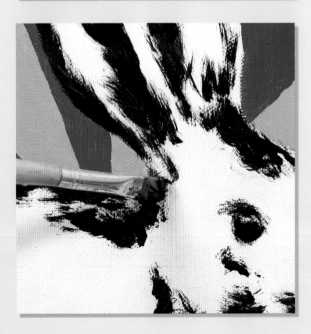

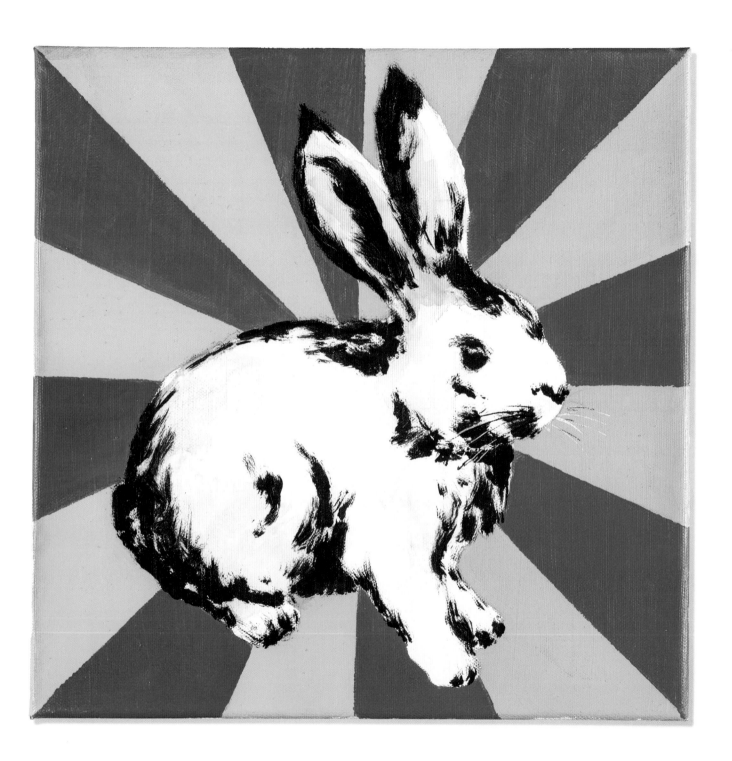

Butterfly

Animals make excellent motifs for Pop Art paintings, and this applies to the very small as well as the very large.

For this picture, I have chosen a magnificent butterfly, whose striking colour is further enhanced by a brightly coloured frame. Again, the black outlines are important! The combination with the white light reflections creates a comic book-style effect.

Materials

* Square stretcher frame, 30 × 30cm (11¾ × 11¾in)
* Acrylic paint: titanium white, cadmium red, cyan, pea green and black
* Paintbrushes: size 12 flat and size 2 round
* Black and white marker pens
* Cardboard strips
* Ruler
* Pencil

1 Transfer the drawing from a photo, or draw a pretty butterfly freehand. It's easy to transfer it to the stretcher frame using the grid method (page 17). Then fill the background in cadmium red.

2 Colour the wings in slightly lightened cyan. Apply a darker mixture of black and cyan to the tips of the wings. This dark blue is also used for the body. Then paint a stripe in pea green just inside the outer edge of the stretcher frame. Use the cardboard strip like a ruler, and draw the brush along it. Repeat this process down the outer edge in cyan.

3 Now draw the outlines, the veins on the wings and the little hairs on the body in black marker pen. Add a few bright light reflections in white marker pen. Alternatively, you can use the detail brush instead of the white marker.

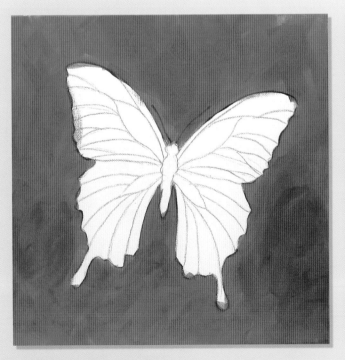
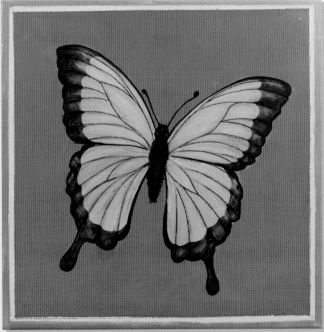

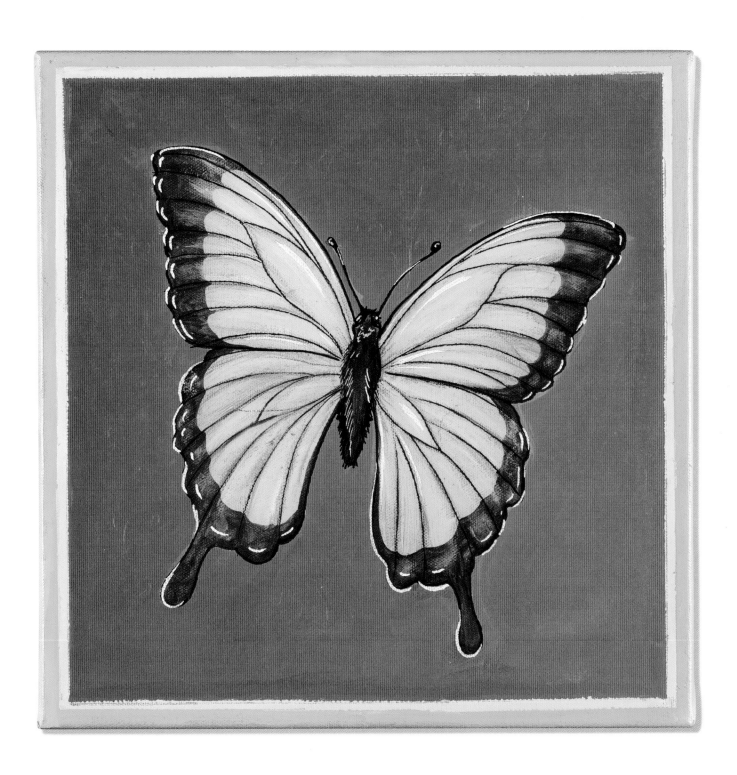

Pear

Everyday objects also make lovely motifs for a Pop Art picture. Do you happen to have an apple or pear to hand? Take a bite out of it, then paint it.

This picture is distorted slightly to make it like a comic book motif, in particular by the irregular dark outline.

Materials

* Stretcher frame, 30 × 40cm (11¾ × 15¾in)
* Acrylic paint: Naples yellow, white, cerulean, pea green and black
* Paintbrushes: size 10 flat, size 14 flat, size 2 round
* Pencil

1 Use thin pencil strokes to sketch the preliminary drawing on the canvas. Paint the background in cerulean blue lightened with a little white.

2 Paint the fruit in Naples yellow and the stalk in a combination of yellow and green. Then lighten the yellow-green of the stalk with white, and paint the flesh around the bite mark.

3 Apply the dark contours with the size 10 flat brush. Keep them slightly uneven – the increase and decrease in the line creates a lively effect. Add two light reflections on the left side of the pear in white.

4 When the paint is dry, lighten the blue of the background with a little white, and paint a dynamic line around the edge of the frame. Aim for a slightly irregular shape, a little like the tears in a paper collage.

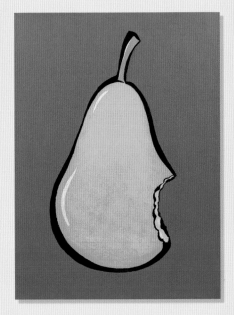

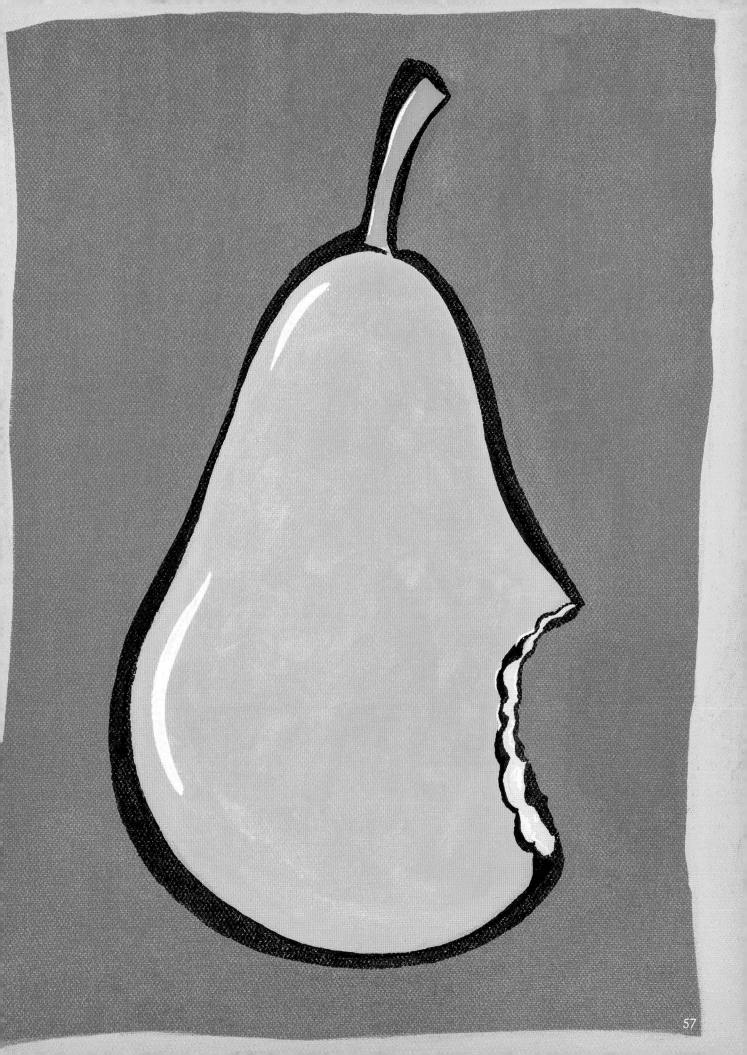

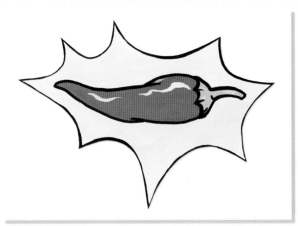

Hot Chilli

In comics, explosions, flashes and loud noises are often signified by brightly coloured spiky shapes behind the words 'boom' or 'bang'. Instead of a word, this painting has a red-hot chilli pepper in the middle of the explosion!

Rather than being painted onto the surface of the canvas, the motif in this project is a collage of cardboard mounted on the canvas.

Materials

* Stretcher frame, 30 × 40cm (11¾ × 15¾in)
* Acrylic paint: cadmium red, black, white, yellow, royal blue and green
* Orange and silver card
* White watercolour paper
* Paintbrush: size 12 round
* Fine detail brush or black marker pen
* Scissors, glue, sticky pads or tape
* Pencil

1 Start by sketching the zigzag explosion shape. Have a look at some comics or in the Internet for inspiration. When you have drawn two shapes, transfer one to the orange cardboard and cut it out.

2 Paint a simplified chilli pepper on the watercolour paper and colour the background in yellow, the chilli in cadmium red, and the stalk in green. Cut the shape out and add a black outline to the chilli pepper and the explosion shape.

3 Paint some red rays on a piece of silver card and colour the outlines in black pen.

4 Paint the stretcher frame in royal blue. Cut out the rays and glue them to the stretcher frame.

5 Cut a further explosion flash out of silver cardboard. Then stack the shapes and glue them together as shown here. If you want to increase the three-dimensional effect, stick small pieces of corrugated cardboard between them.

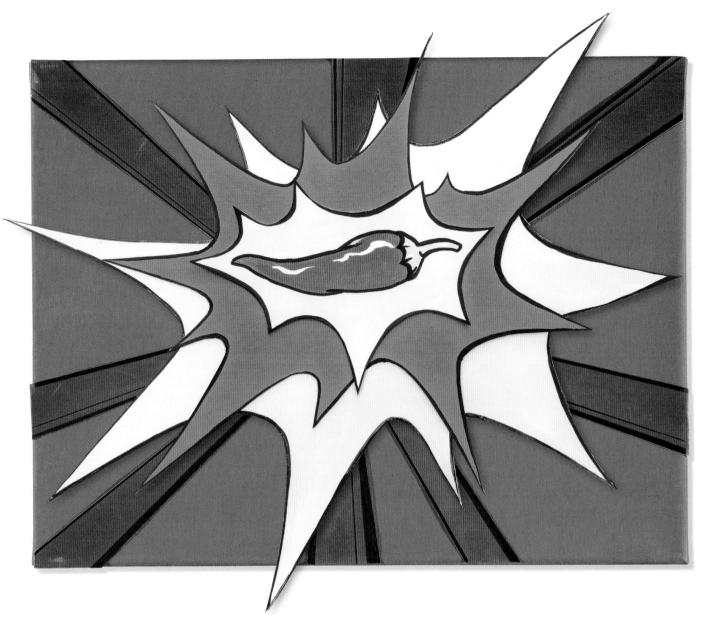

Alternative:

The chilli pepper also works well without the coloured stretcher frame. For this alternative approach, simply omit steps 3 and 4. This will leave your picture finishing with the tips of the spikes rather than being rectangular. You can attach this collage directly to the wall using sticky pads.

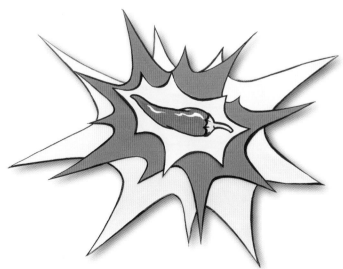

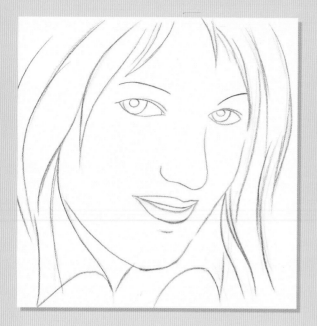

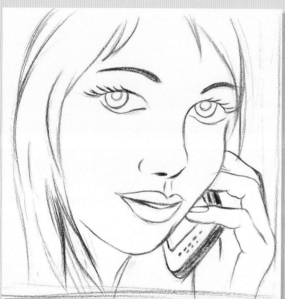

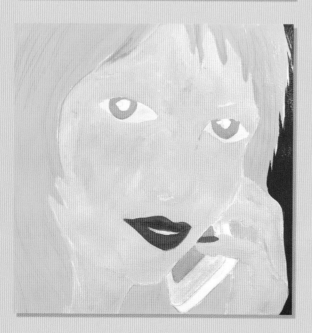

Smartphone

This portrait is a lovely example of the comic style. It is adapted from a photograph of a woman with her head in a typical 'on the phone' position. Back in the heyday of Pop Art it would have been a large, probably black, telephone receiver, but I have updated it to a smartphone for a contemporary twist.

Materials

* Watercolour paper, 30 × 30cm (11¾ × 11¾in)
* Acrylic paint: white, skintone, black, cadmium red, cobalt and yellow
* Paintbrush: size 10 flat
* Fine detail brush or black marker pen
* Pencil

1 After tracing a photo you will have a good base for completing your picture. The girl seen in this picture still looks quite real.

2 You need to make a few changes in order to achieve the comic book look. Make the eyes bigger, the lashes longer, the chin shorter, the lips fuller, and the nose shorter and a little blunter. Give the right side of the face, for instance the cheekbone, an eye-catching contour. Then add a hand with a smartphone. Again, you can base this on a magazine photo. Now transfer the comic book-like drawing to the cardboard.

3 Paint the various areas of the face, using the skin tone paint for the majority of the face, leaving out the eyes, nostrils and mouth. Paint the hair yellow. Use cadmium red for the lips and nails, and cobalt for the narrow stripe on the right side of the picture. Allow all the paint to dry completely.

4 Go over all the outlines with the fine detail brush and black paint (alternatively, you can use the black marker pen). Avoid making the lines all the same, but allow them to become thicker and thinner. Gather the hair in strands. Colour the thin side of the smartphone in black, and add a bright reflected highlight to the corner in white.

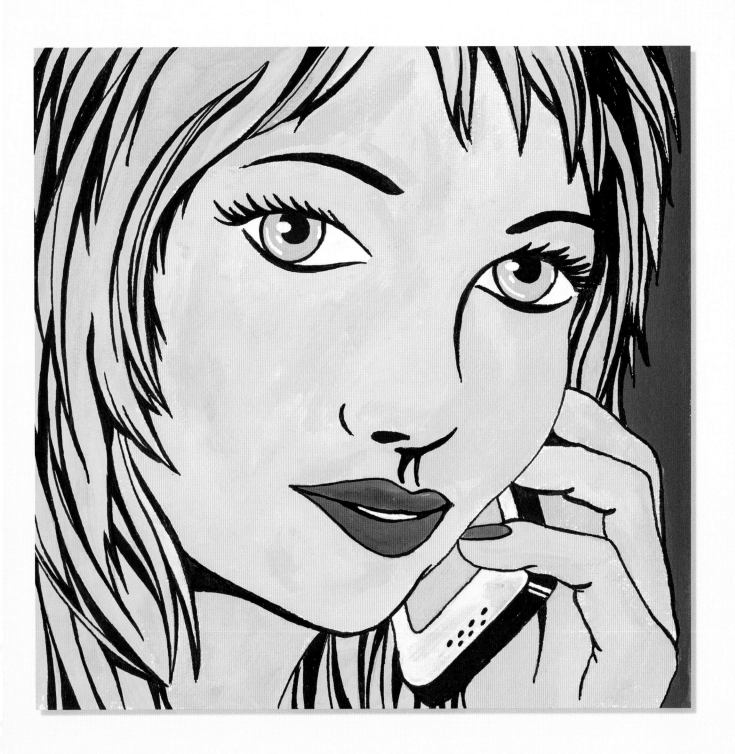

High Heel

This shoe quite literally steps out of the frame! Here I have extended the subject beyond the conventional rectangular frame through simple means: painting paper on polystyrene. If you prefer, you can use other easy-to-cut materials in place of the polystyrene, such as wood or fibreboard.

Material

* Acrylic painting paper, 30 × 40cm (11¾ × 15¾in)
* Polystyrene board
* Acrylic paint: royal blue, black, carmine, white and cadmium yellow
* Paintbrush: size 12 flat
* Black and white marker pens
* Cutting tool and mat
* Ruler
* Pencil
* Solvent-free glue

Tip:

Check that the adhesive you are using can be used on polystyrene by testing it on an off-cut first. Some solvent-based adhesives can cause polystyrene to dissolve.

1 You can use any suitable photograph of a shoe to help with the preliminary drawing. It is a good idea to sketch it first to get the proportions right, then exaggerate the shape, particularly the height of the heel. Next, transfer the sketch to the painting paper and paint it using carmine for the shoe and blue for the background. Mix white with a little yellow and carmine for the cream-coloured interior.

2 Go over the outline with the black marker pen. Add some extra rounded lines near the sole and heel to give the shoe more shape. Next, paint a black frame around the shoe, leaving the toe over the edge. Use the paint undiluted, so that obvious brush lines are left as shown. Paint a shadow under the shoe, then add a few additional white highlights to the red paint.

3 Cut out the image, being careful to leave the tip of the shoe protruding over the side of the frames. Place the paper on a sheet of polystyrene, and draw round the outline using a marker pen. Trim the polystyrene into shape neatly using the cutting tool. Note: the sharper the knife, the neater the cuts will be.

4 Glue the paper onto the polystyrene shape and allow everything to dry. To finish, colour the sides of the polystyrene thickly in black.

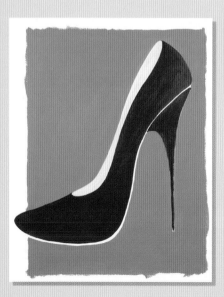

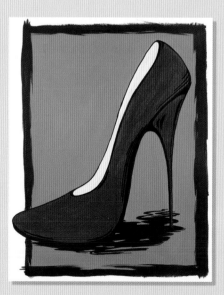

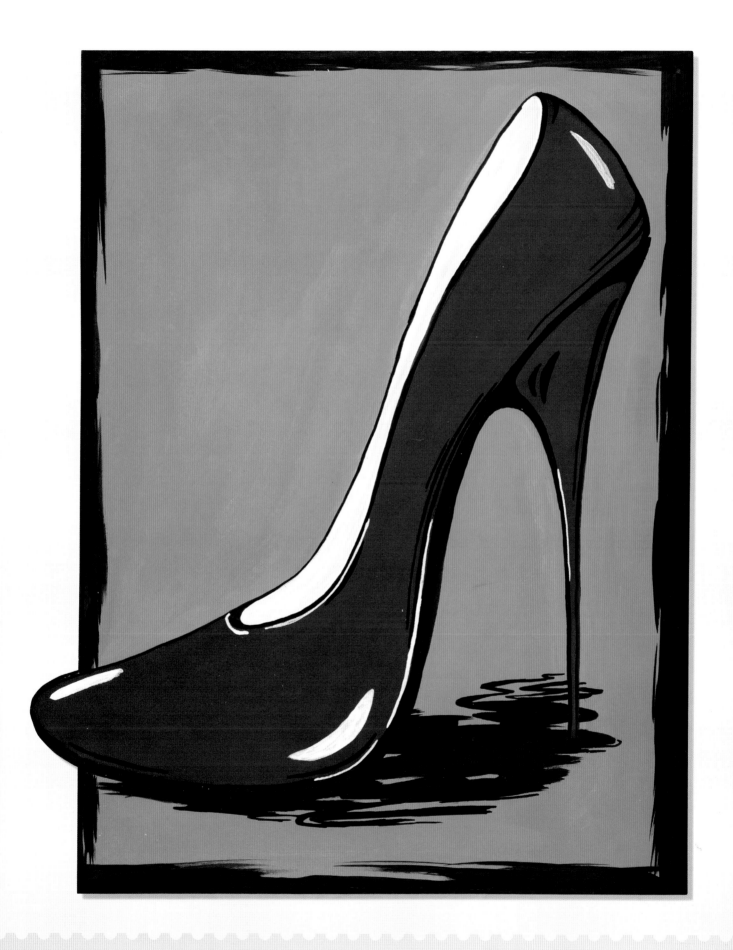

AFTERWORD

Pop Art changed the art scene, and with it our perception of our world. The media was tremendously interested in Pop Artists at the time, and much has subsequently been written about the movement. We can safely say that this art direction polarises people – the Pop Artists found at least as much rejection as they did enthusiastic appreciation – and the effects of the movement are still with us today.

I would be so pleased if painting the Pop Art pictures in this book encourages you to observe your daily surroundings with all its products and brands more closely and also, ideally, with a little perspective – just like an artist who takes a step back to consider his work from a distance, in fact. Try it and see! The aim of my book is to encourage you to be creative and active. In line with this motto, I hope I have smoothed your path to this subject and to painting!